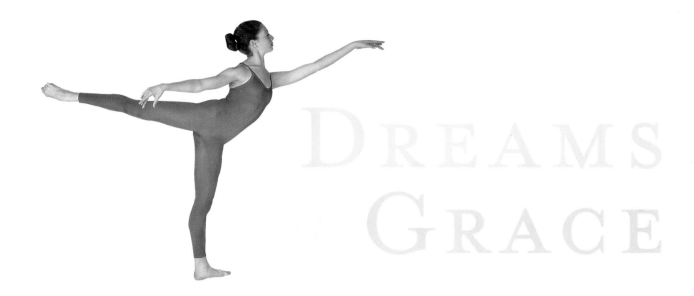

Dreams
Grace

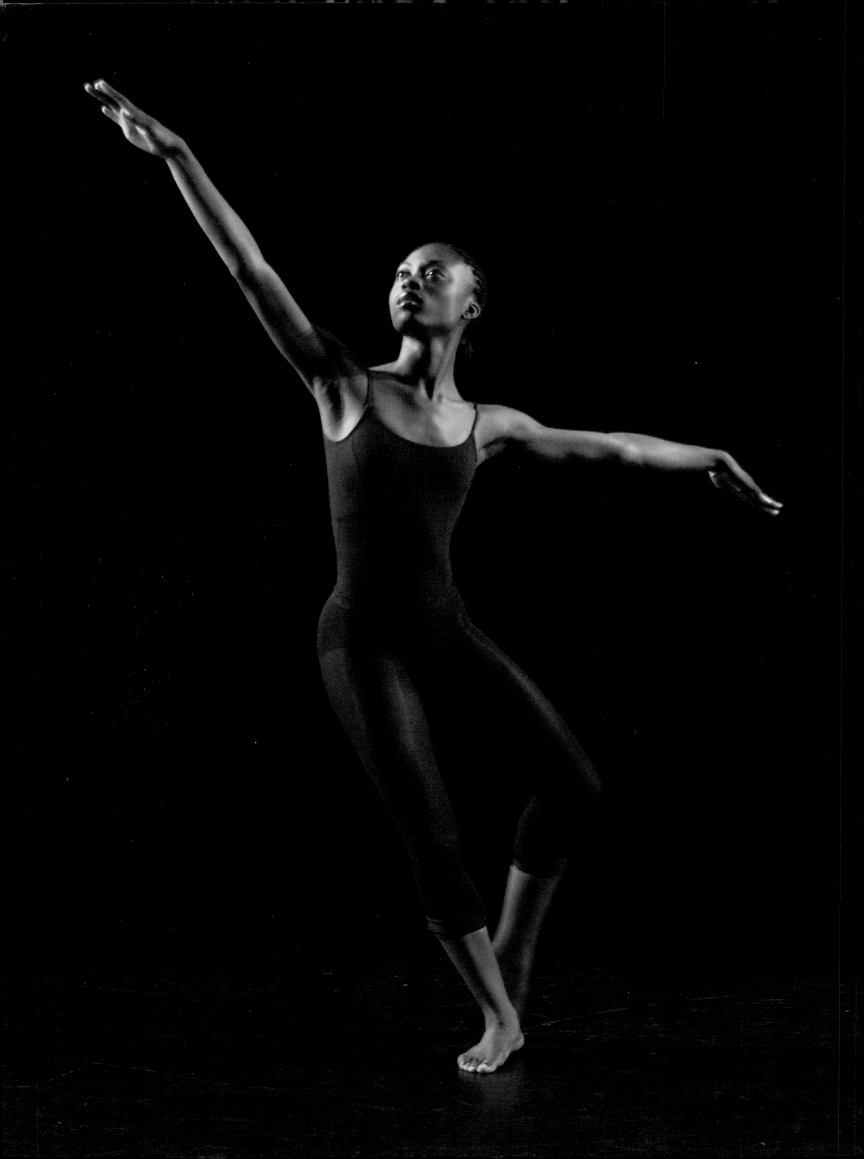

DREAMS
GRACE

IMAGES AND REMEMBRANCES
FROM THE DANCE DEPARTMENT AT FIORELLO H. LAGUARDIA
HIGH SCHOOL OF MUSIC & ART AND PERFORMING ARTS

FRANK PETERS

COVER: Shamel Pitts

PAGE 1: Loni Landon

PAGE 3: Jazmin Nelson

CHOREOGRAPHY CREDITS:

Marius Petipa Staged by Michelle Benash	Pas de Deux from DON QUIXOTE
Elisa King	Yienon's Lilith, Liberation Suite
Penny Frank	A Light Wind
Catherine Brikké	In a Summer Mood
Mathew Neenan	Marsalis
Pat Catterson	The Ballroom
H.T. Chen	Meditations of a Drunken Peacock

This book is published by Money Heaven, Inc. 2003

For information address:
Money Heaven, Inc.
P.O. Box 574
Corona del Mar, CA 92625

Designed by Jonathan Glick

Printed by Dual Graphics
First Edition
10 9 8 7 6 5 4 3 2 1

ISBN: 0-9727139-0-5

Visit www.dreamsofgrace.com

CONTENTS

Thursdays after school,
the dance studios host the
"Breaker Boys and Girls"
where anyone can show
their break-dancing moves.

The idea of the book came about after I e-mailed rehearsal photos to a few friends. I had assembled a mailing list just for such showing off. Simultaneously, Jay Torborg and Steve Eich clicked back saying, "you ought to do a book." After thinking about it for a few days, I raised the subject with Michelle Mathesius, Director of the Dance Department. It's a good thing I was ready to begin right away because there would be no stopping her.

I would like to thank the many people who helped in the creation of this book. Students, past and present instructors, graduates and parents are some of the many contributors to this look at LaGuardia High School.

Thanks to Jana Kolpen for sharing her own book publishing experiences.

To those at the school, I would like to thank my reviewers, Penny Frank, Cedric Tolley and Patrick Byers. Thanks to Farley Whitfield, because without light there is no photography and to Michelle Mathesius for giving me the opportunity. Thanks especially to the many contributors for their remembrances of the school.

I am grateful to my friends: Kent Issenberg who wants me to keep doing this until I'm seventy-five, Jim Mulcahy who told me to get off the beach and keep working, and Roger C. Jeffrey who critiqued the photographs from a dancer's perspective. During the final reviews, Mary Mulligan, Lisa Goodall and my mother contributed greatly.

Lastly, I wish to thank my wife, Barbara, who has always encouraged and supported me, especially while I've pursued this new career.

Randy Castil

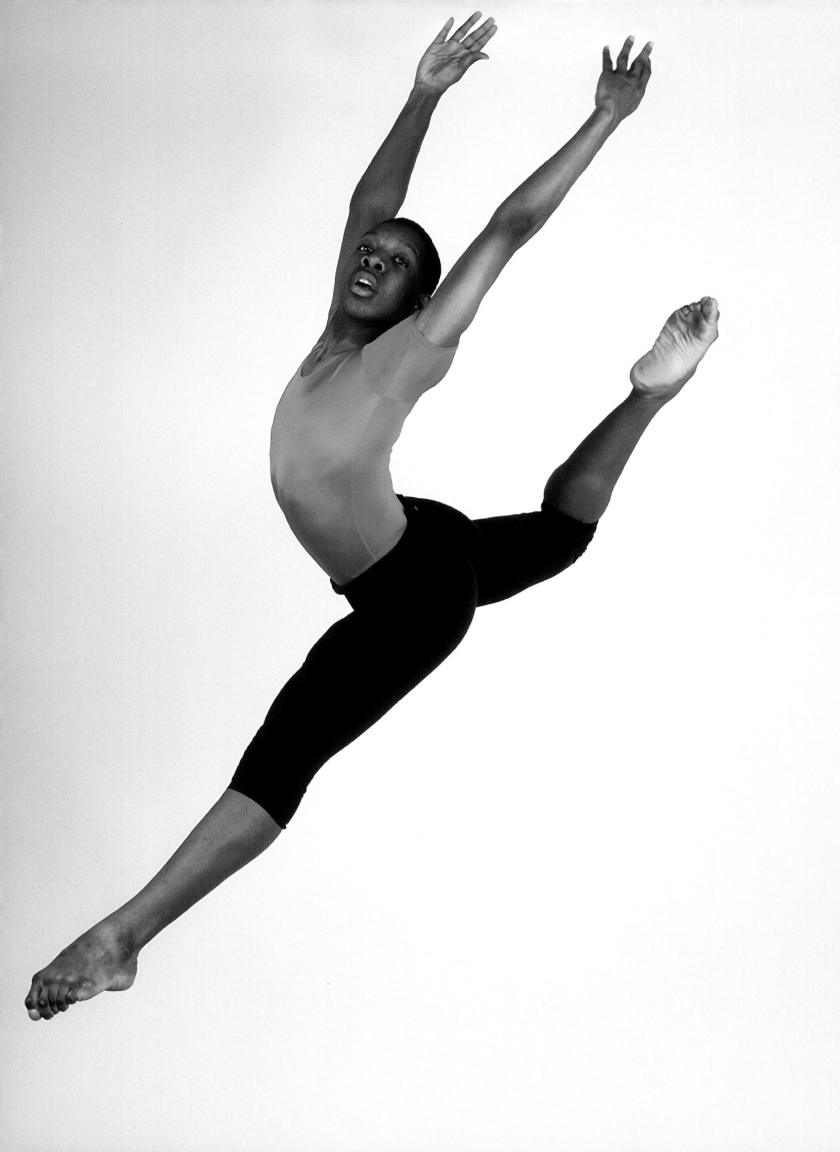

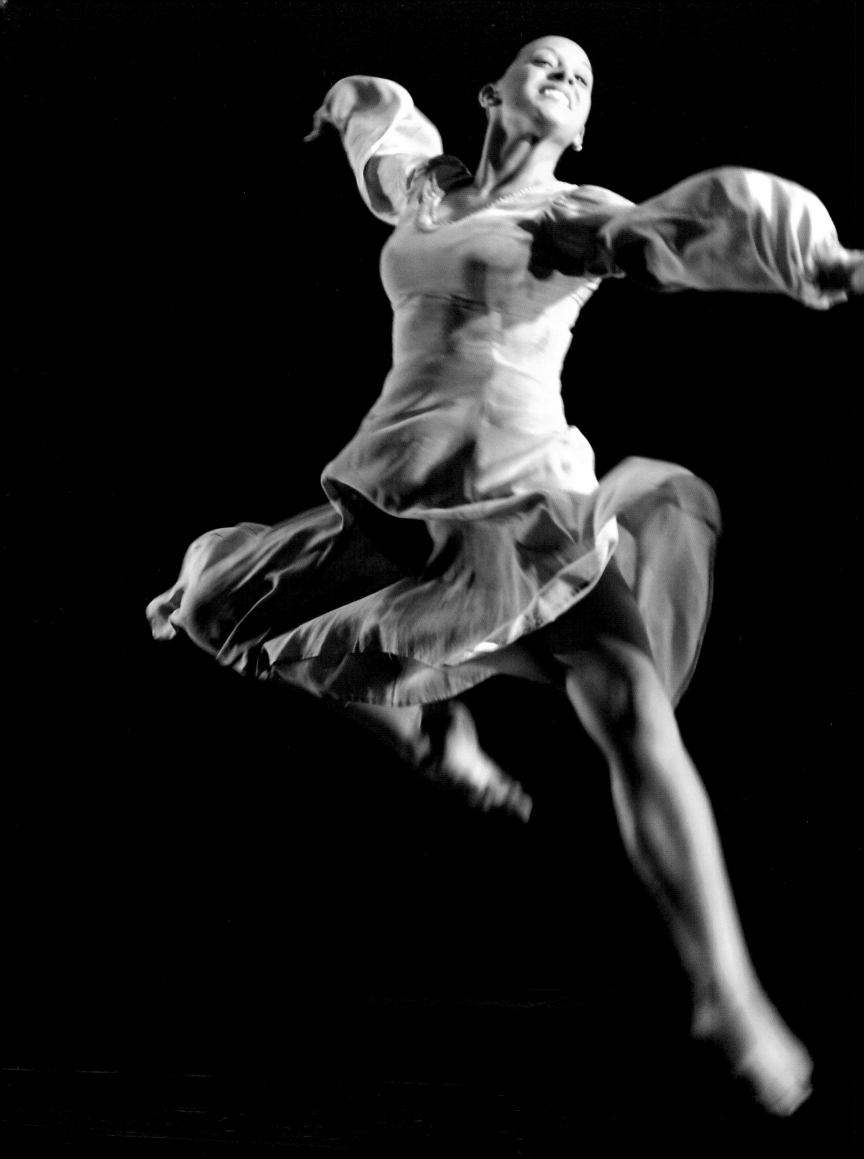

TAKING OFF ON A NEW CAREER

Frank Peters

This book is about the Dance Department at LaGuardia, famous for turning out some of the world's greatest dancers.

What is LaGuardia High School? It is a public high school in New York City. It is no ordinary high school. To get into this school a student has to apply or audition. LaGuardia's tag line states "of Music & Art and Performing Arts." The performing arts include Dance and Drama. Performing Arts, or PA, was once a separate school on 46th Street. The school was the inspiration for the movie and TV series, "Fame."

Here's how I became involved at LaGuardia High School.

"Everyone should have five careers in their life," offered my friend Lisa Goodall. I wondered where I was on that scale. I had just finished a fifteen-year career in software and now I was retired at forty-five. I had time to play golf, travel and spend quality time at home with my wife and two sons. But I was too young for all this leisure. All my friends were busy with their careers. Retirement was isolating. I was wrestling with the direction of my life.

My family and I moved to a home on the California coast, but kept our apartment in New York. That first winter at the beach was inspiring—the sunsets were grand. Out came the camera. I'd later have to answer, "Mr. Peters, how long have you been taking pictures?" A long time, more than thirty years, but always just as a pastime, was my response. Now photography could take up all the time it wanted.

Studio work appealed to me; partly, I suppose, because I'd never done any. Finding the equipment was easy and I began shooting in the New York apartment.

I soon found volunteers to sit for portraits. Back in California, I set up a studio in the garage. Soon, there were more volunteers. I set a goal to log a hundred hours in the studio; that would polish my skills.

OPPOSITE: Kristel Sterbenz

Ironically, my landscapes were gaining attention, in particular, photos of a lily pond in upstate New York. As I worked on one lily pad composition, Jymm Mooney was looking over my shoulder. Jymm was doing interior design improvements to the apartment, but at this moment his input was needed on a photo design. His previous client had been Michelle "Mickey" Mathesius, of LaGuardia High School's Dance Department. Something in his mind made a connection. He picked up the phone and I was invited to visit the school the very next day.

I was excited. I'd heard that the dancers needed photos and the school was conveniently located, only two blocks away. That was a good enough fit for me.

I wondered what to bring, quickly ruling out a camera as too presumptive. A light meter would tell me what shooting inside the school would be like. And photos—I quickly put a portfolio together.

The next day I was standing in front of Mickey's office for the first time. After a quick how-do-you-do, we were off on a tour of the classrooms. The studios were filled with dancers. I fiddled with the light meter. The classrooms were pretty dark, and those fluorescent lights...argh!

We visited the next studio, then on to another. Four huge dance studios provided a ton of material to shoot.

Lily pads at Mohonk

OPPOSITE: Xiaolin Fan

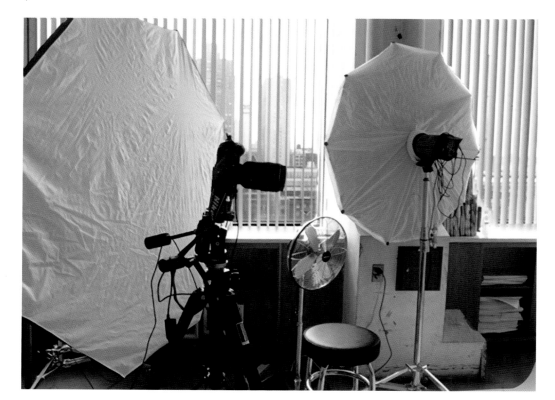

*A few improvements,
and the studio began
to take shape*

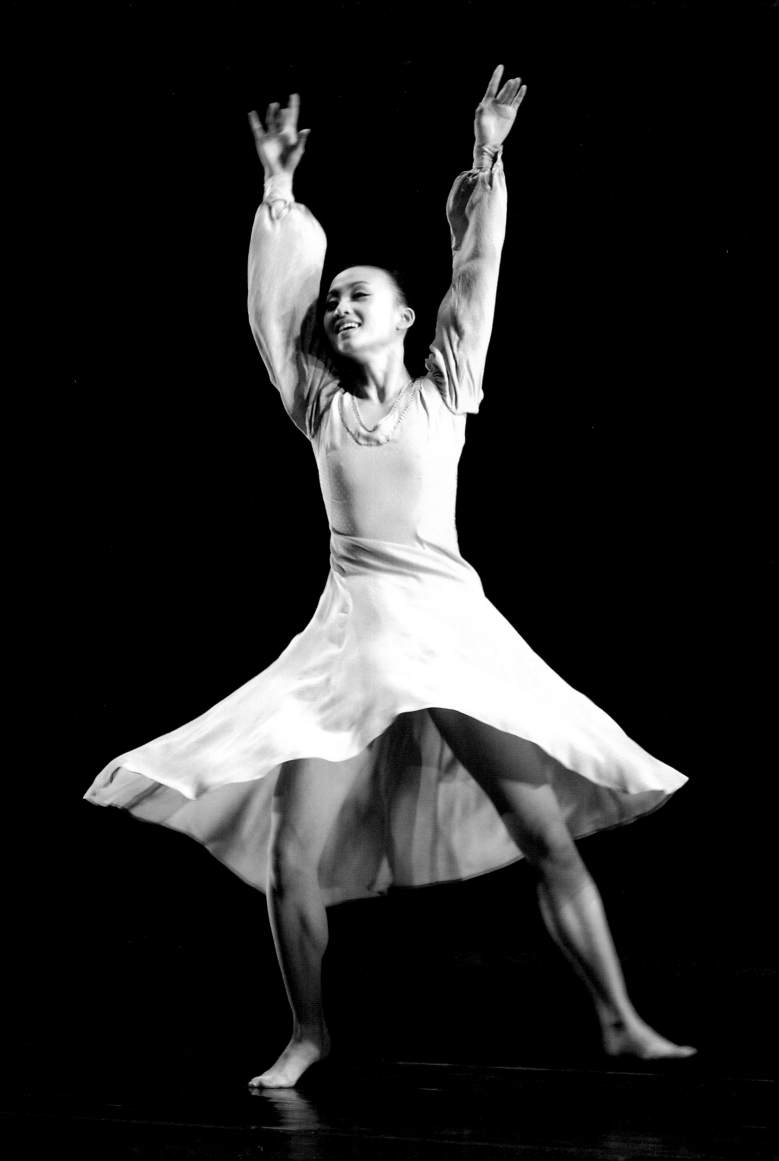

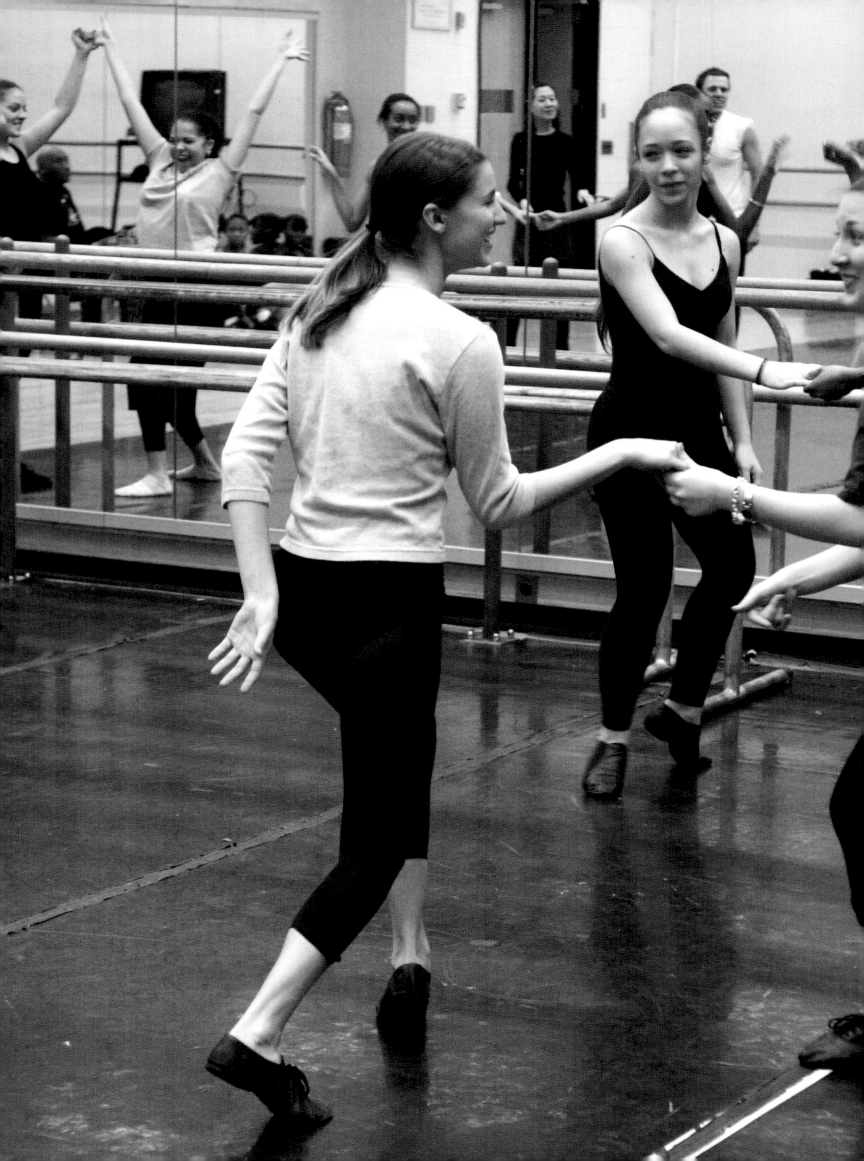

PHOTOGRAPHS
by
FRANK PETERS

We walked back to Mickey's office. She showed me the adjacent storage room—twenty-foot ceilings, a wall of south-facing windows—it was perfect. "You can use this as your studio," Mickey offered. I'll never forget my delight. What an opportunity! We arranged our next meeting and said our goodbyes.

It had been an exciting day. I was beginning a new career. It was only as I settled in late that night that I realized I had not shown Mickey a single photograph.

As I'd later reflect on my beginnings at LaGuardia, I felt that my challenge was to live up to the assumptions the school had of me. Hopefully, the images contained here show that I did.

Headshots with Frank

Do's

- ❑ **Wear a Black Top**
 Spaghetti Straps or V-neck
- ❑ **Makeup**
 Powder Your Nose
- ❑ **Lipstick**
 Darker than usual is OK

Don'ts

- ❑ **No Turtlenecks**
- ❑ **No Insignia**
- ❑ **No Earrings**
- ❑ **No Jewelry**
- ❑ **No Lip Gloss**

Natalie Cohen in turtleneck!

The students needed headshots for their portfolios. I volunteered to shoot them. The studio was built with lighting arranged on stands and hanging from the wall. Rolls of colored paper could be pulled down to provide a seamless background. Everything was ready; everything except the dancers.

Few of them had spent much time in front of a camera. Frozen smiles and awkward poses begged, "tell me what to do." I had assumed that this would be the easy part.

They were interested in the camera, especially in taking the photos themselves. So that's how I broke the ice. I taught a few students how to meter the light, hold the trigger, compose the shot and fire. The subjects responded better with their peers behind the camera. The junior photographer got his subject to relax with a cajole or a purr. More kids crowded into the room, intrigued by the commotion of catcalls and crowing. A sexy pose elicited howls from the crowd. It got to be so much fun that it became a problem; taking pictures was more fun than going to class. More students piled into the studio to watch. And the group shots, the kids with their pals, were even more riotous!

Most shots were made using a digital camera. It saved time. I could shoot ten headshots and bring them in the next morning. My audience loved this instant gratification. Mickey would arrange the pictures in display cases for everyone to see. A nice shot would bring lots of attention to the subject. The jitters were gone. A line was forming outside the studio door and inside you'd hear jargon like "quiet on the set!"

Digital technology keeps improving. Beginning with the Class of 2002, the shots would instantly appear on a laptop screen. No more squinting to see the camera's tiny view screen. Now everyone in the room could see the shot and consensus entered the equation.

No one likes their own image. We know where every blemish is, making us hypercritical. Often a subject would say, "I don't know, which one do you like best?" Technology changed all that. Now, with an array of images displayed for everyone to see, majority ruled. A shot with the subject's eyes closed never failed to get a laugh. But for those really good shots, we'd all know the verdict. One of the highest compliments would be, "You look ugly!" Reverse psychology combined with a backhanded compliment. The subject breathed a sigh of relief and the next student stepped in front of the lights.

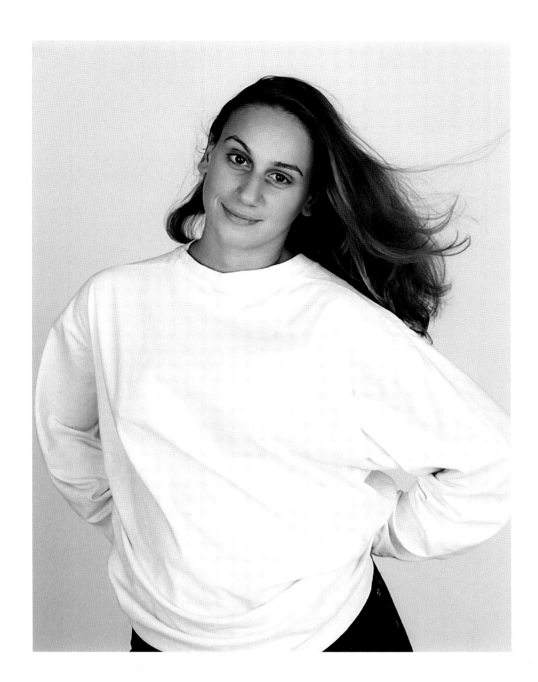

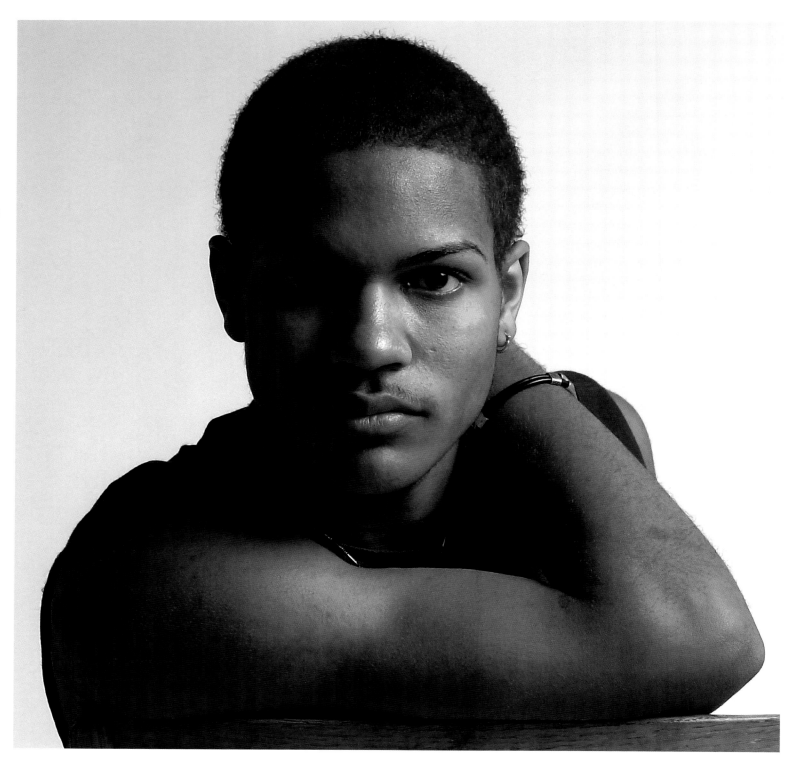

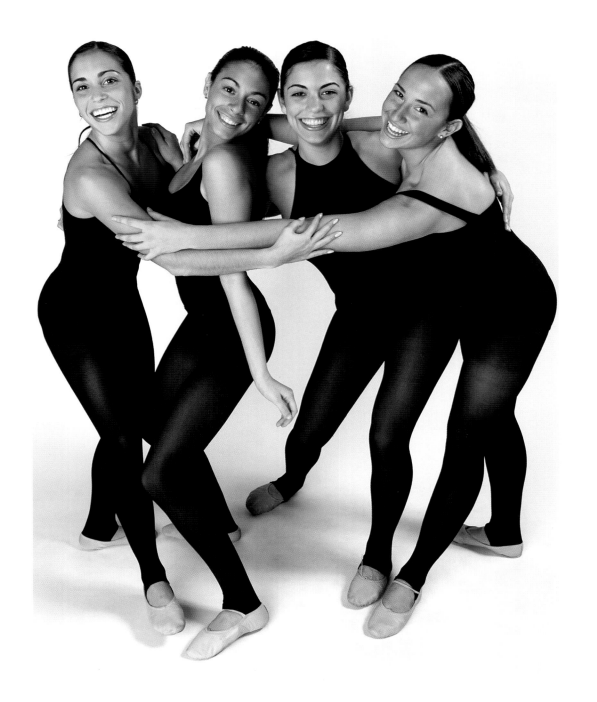

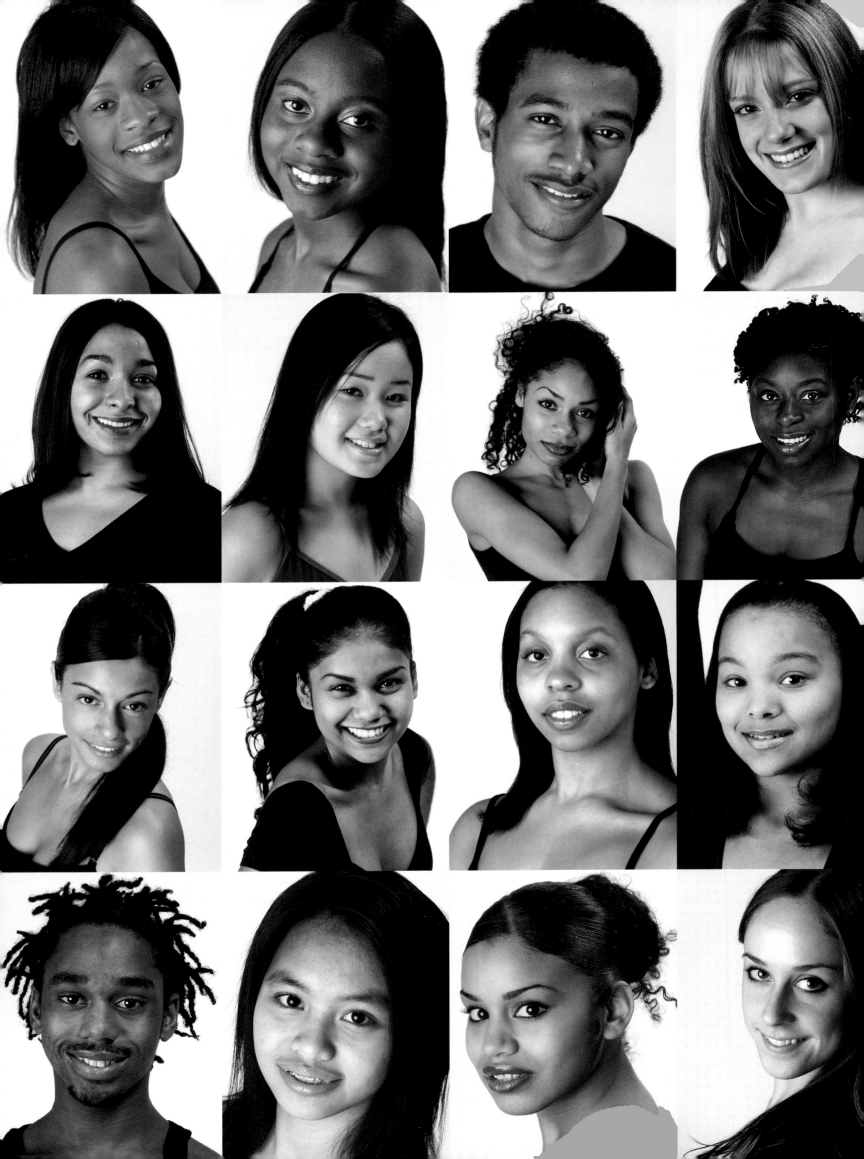

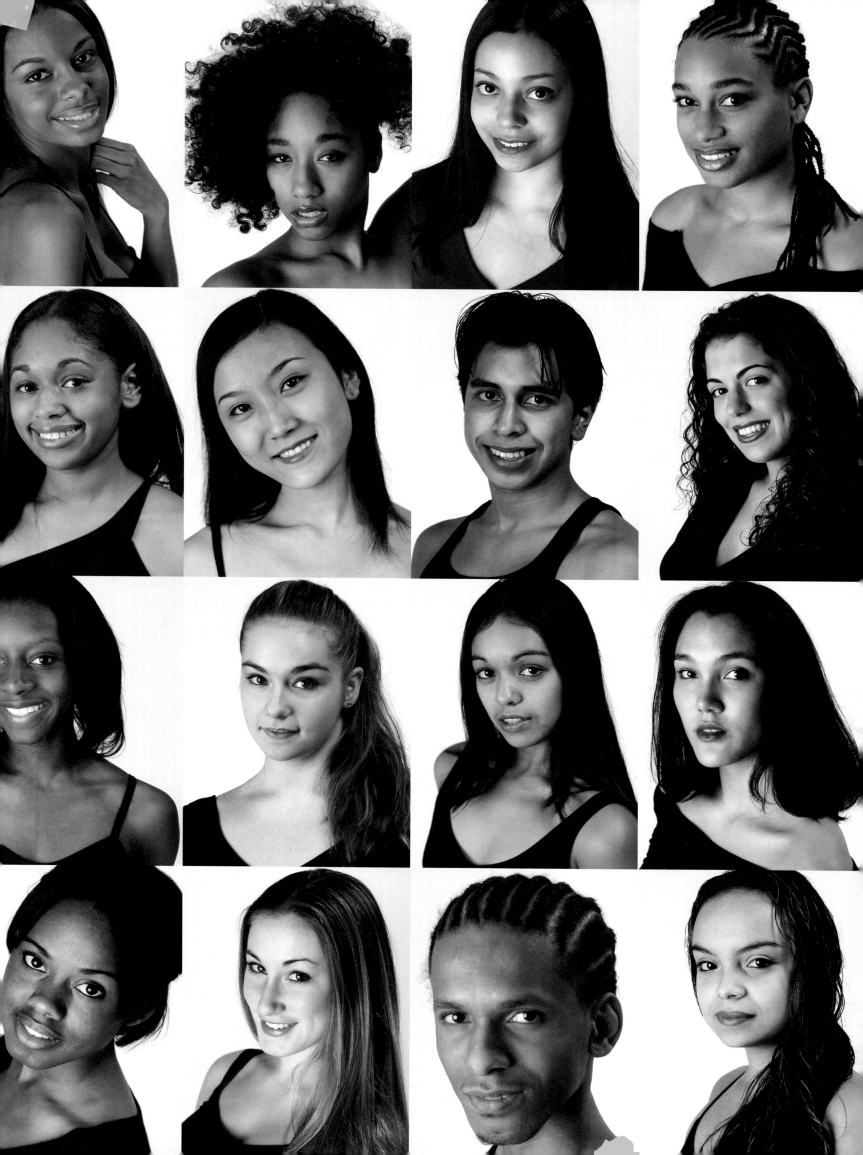

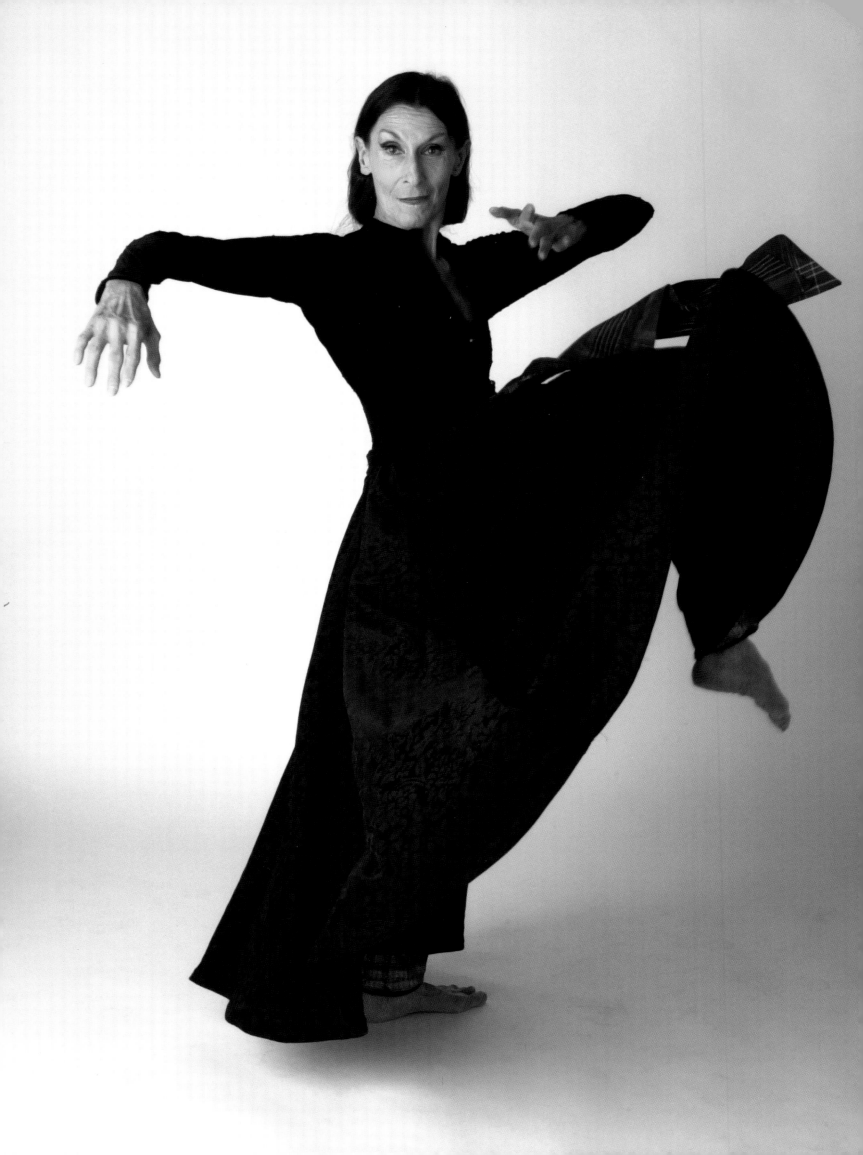

At LaGuardia I was constantly pushed towards greatness.

William Isaac, Alum, the Alvin Ailey American Dance Theater, Dance Theatre of Harlem,
Complexions, Lines Contemporary Ballet and Philadanco

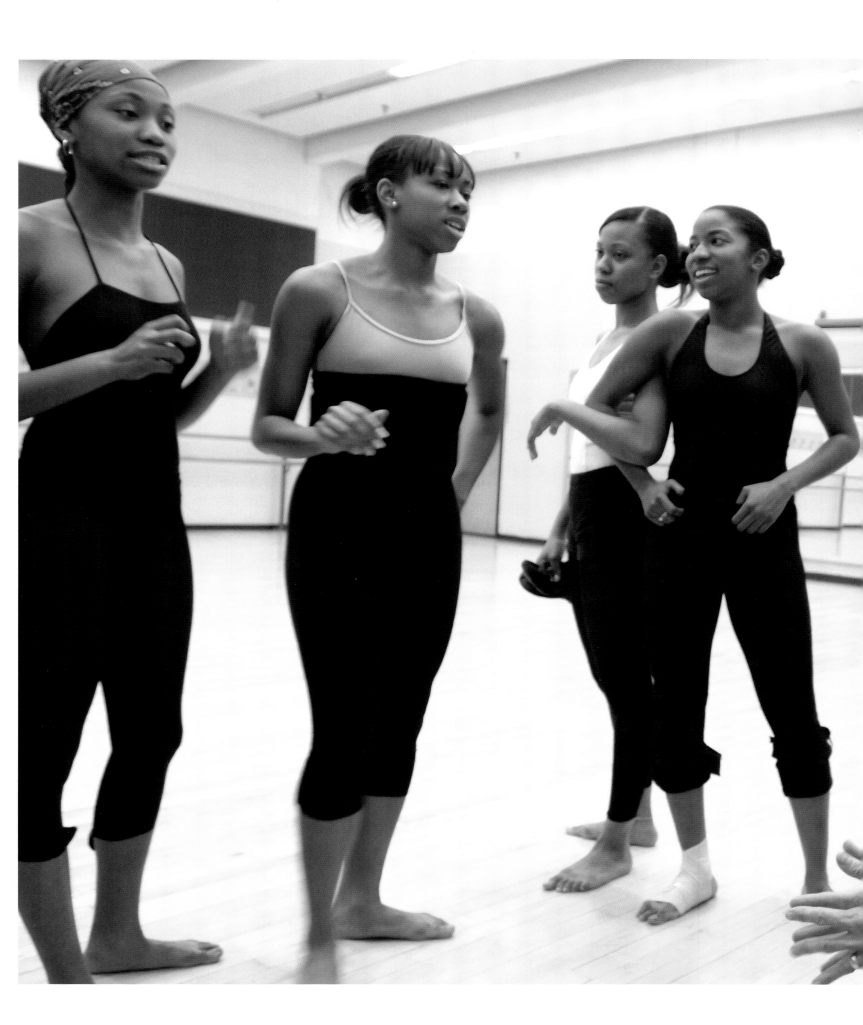

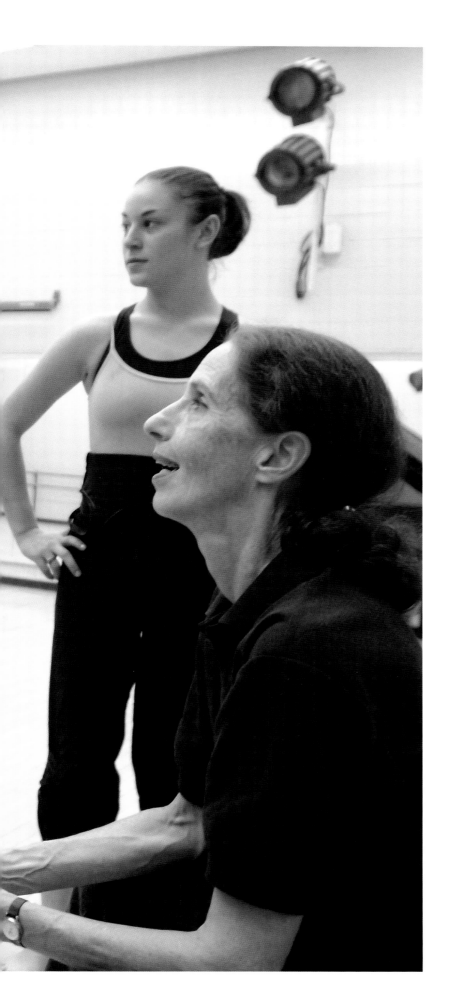

Penny Frank is truly a blessing; I will forever sing her praises. She taught me "brilliance is not happenstance, but hard fought through focus and diligence."

Desmond Richardson, Alum; Artistic Director, Complexions; Principal Dancer, Alvin Ailey; Frankfurt Ballet; Principal Dancer American Ballet Theatre; Tony Award nominee for Fosse

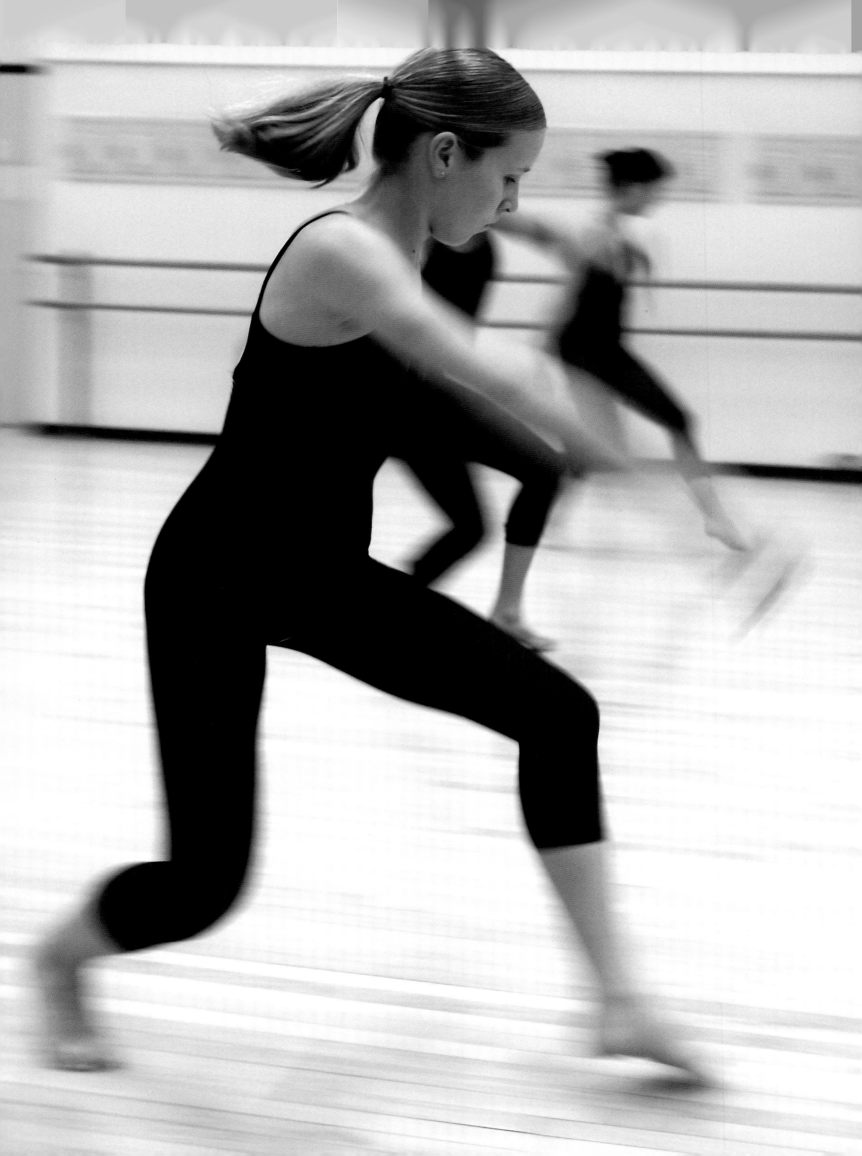

Why do I love teaching?

It's the process of communication that fascinates me. I'm amazed each time my students are able to reproduce what I've shown them, translating my gestures and words into movement.

Penny Frank, Dance Instructor at Performing Arts/LaGuardia since 1968; Former Member of the Martha Graham Company; Joyce Trisler Company; and Juilliard Dance Theatre

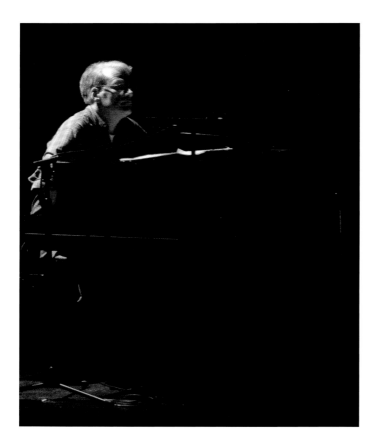

I am a dance musician, one of six here at LaGuardia.
Three times a day I sit at the piano in a dance studio.
Assembled around me, at the barre, on the floor
or whirling through space, are the student dancers,
whose motions are directed by the dance teacher.
Together he and I are making all this movement
possible.

I view my job above all else as helping the
dancers move. At times they glide, at times they
skitter, and at other times, they fly—and they are
dependent upon the music to help them accomplish
these movements with vitality and precision.

For twenty-seven years now I have worked with
dancers—in dance companies, professional dance
classes, universities and dance academies—but in
no other environment have I encountered such a
range of personalities, such diversity of temperament,
outlook and background. Vibrant, charming,
unpredictable, wonderfully sweet, impulsive, and
often outrageous, our students are at all times
demonstrably and even defiantly *themselves*.
Only at LaGuardia can you find such a mix,
because these kids come to us from all five
boroughs of the most diverse city in the world.

Cedric Tolley, Dance Musician

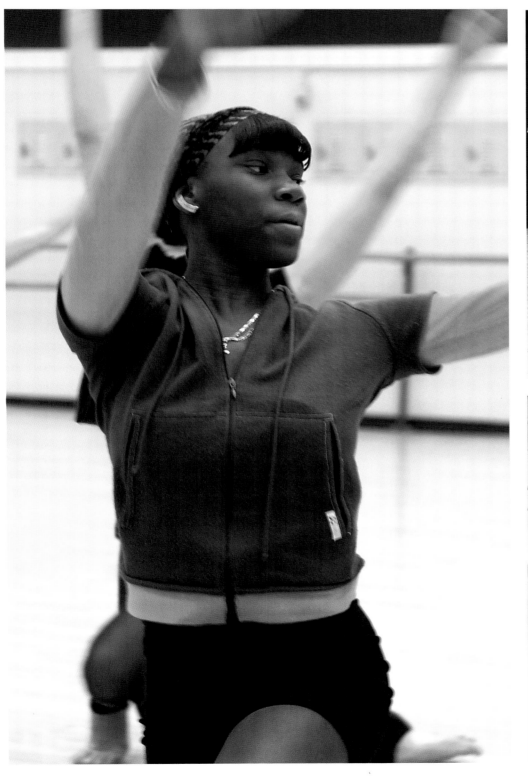
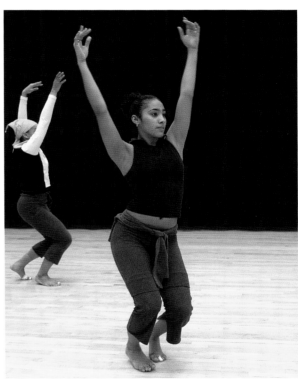
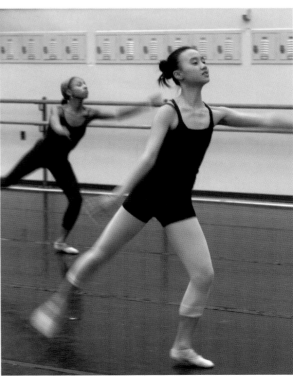

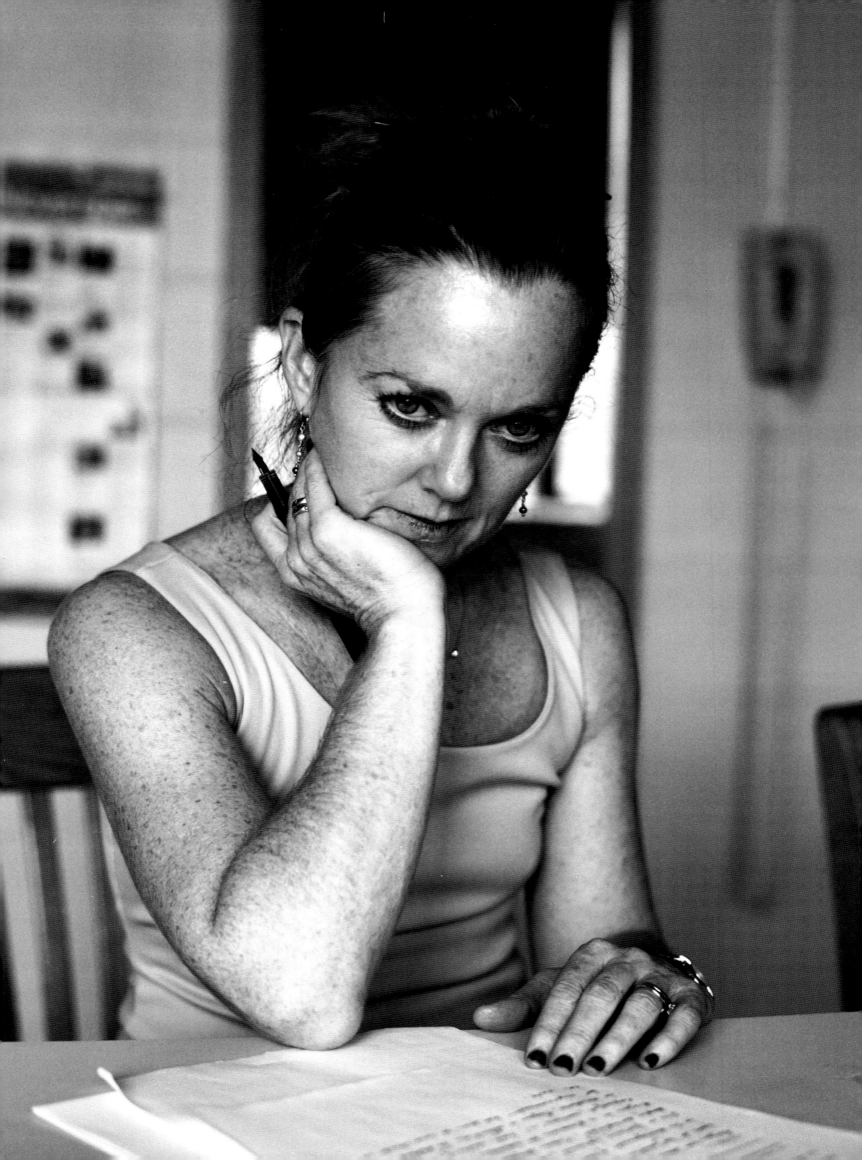

42 Michelle Mathesius and the Dance Department have been my backbone. To this day, while I was in companies, on Broadway, doing musicals or choreographing, I could reach back and find help in my ventures, concerning the arts and life. This department is not just a four-year course; it's a lifetime warranty.

Troy Blackwell, alum

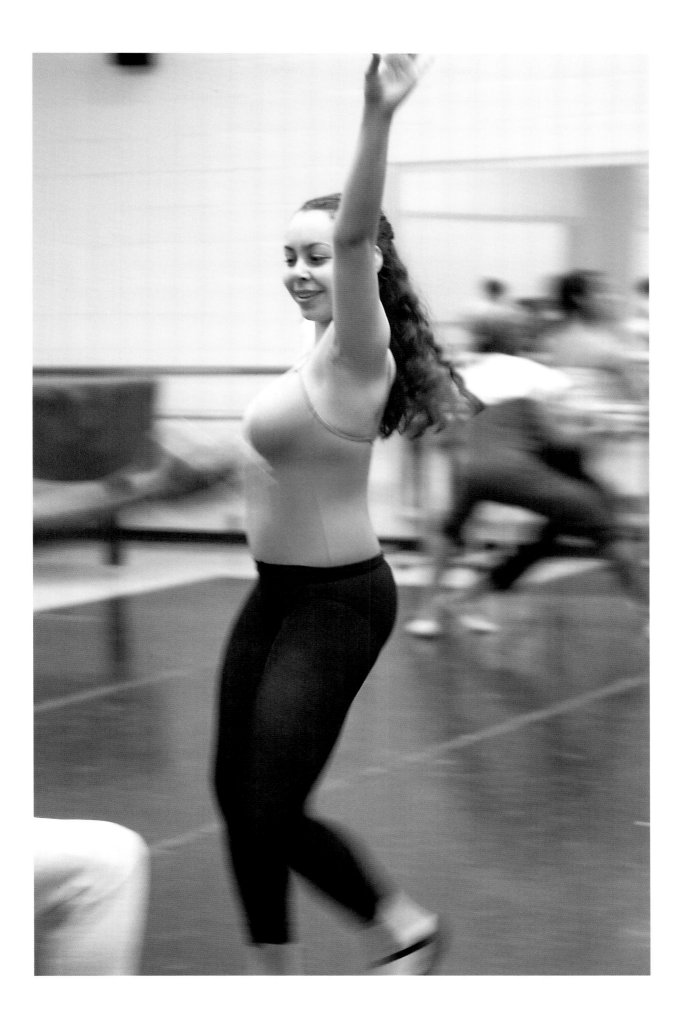

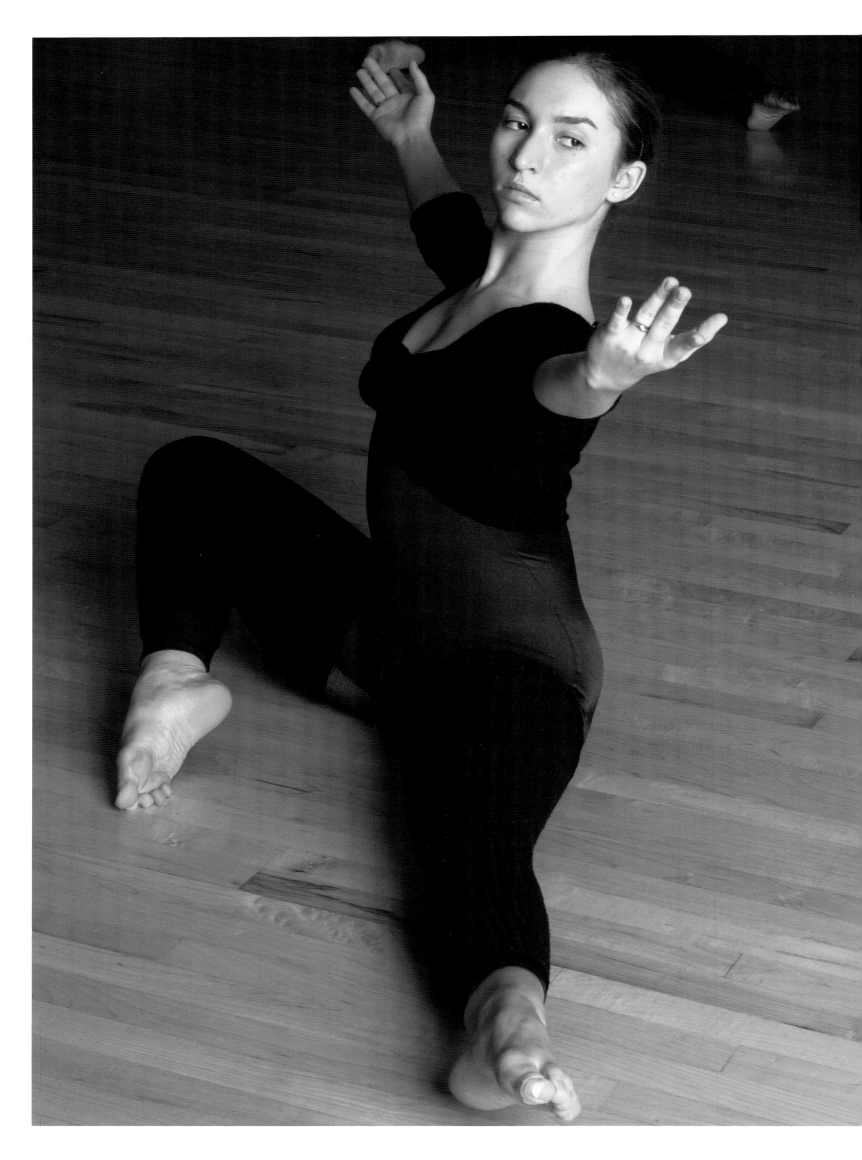

Fifty-odd years ago, I auditioned and was accepted at Performing Arts High School, on 46th Street, the "old school." I was frightened beyond words! The entire staff was seated in front of me: Lucas Hoving, Nancy Lang, Bella Malinka, Lillian Moore and Robert Joffrey.

Each year that I participate in the auditions at LaGuardia, I am reminded of that time. I can truly understand the anticipation and nervousness felt by the young dancers who arrive, having had little or no training.

Having retired after twenty-five years of teaching and choreographing, fourteen of which were at my alma mater, my greatest joy is seeing the new generation of dancers, many I was partially responsible for training.

Brunilda Ruiz, Founding Member of the Joffrey Ballet;
Graduate and Instructor at Performing Arts/LaGuardia

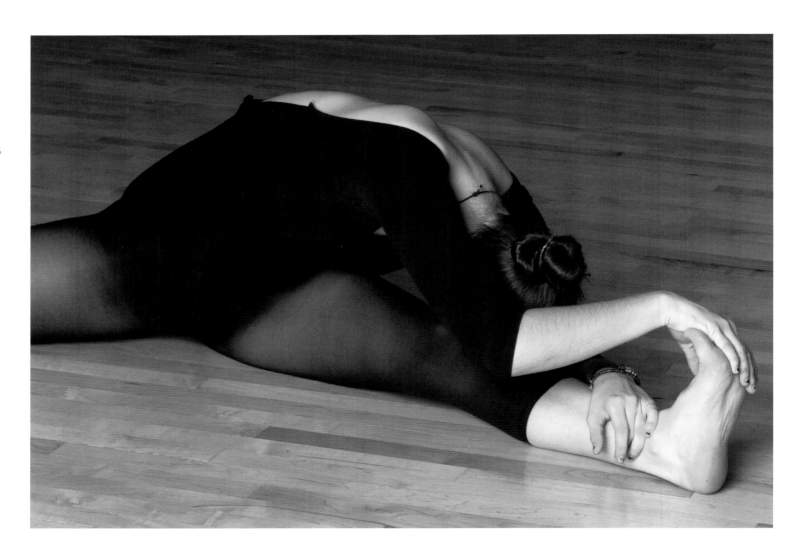

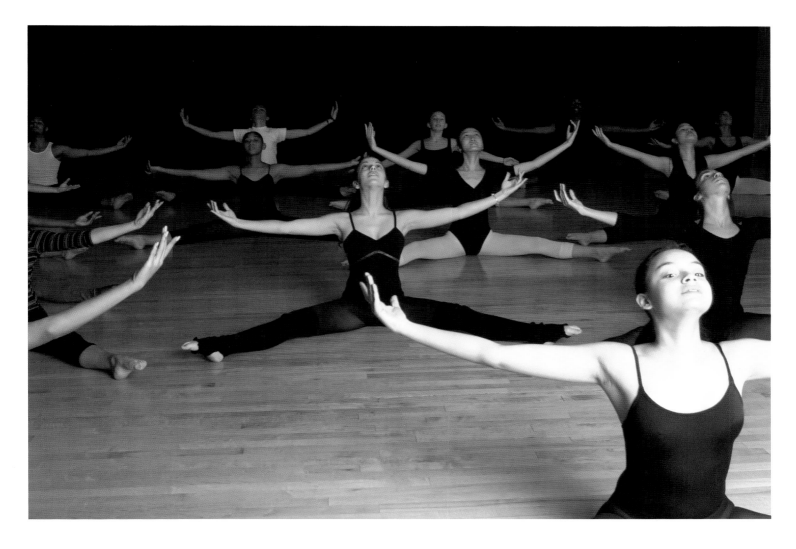

There is so much energy in the dance studio. The students soar, encouraged by talented instructors. Each dancer's creativity is nurtured. No dream is out of reach.

I know my daughter's years at LaGuardia will be rich; and on the day she leaves, it will be with the soul of a dancer.

Ruth Pickholz, Co-Chair, Dance Department PTA, 2002–2003

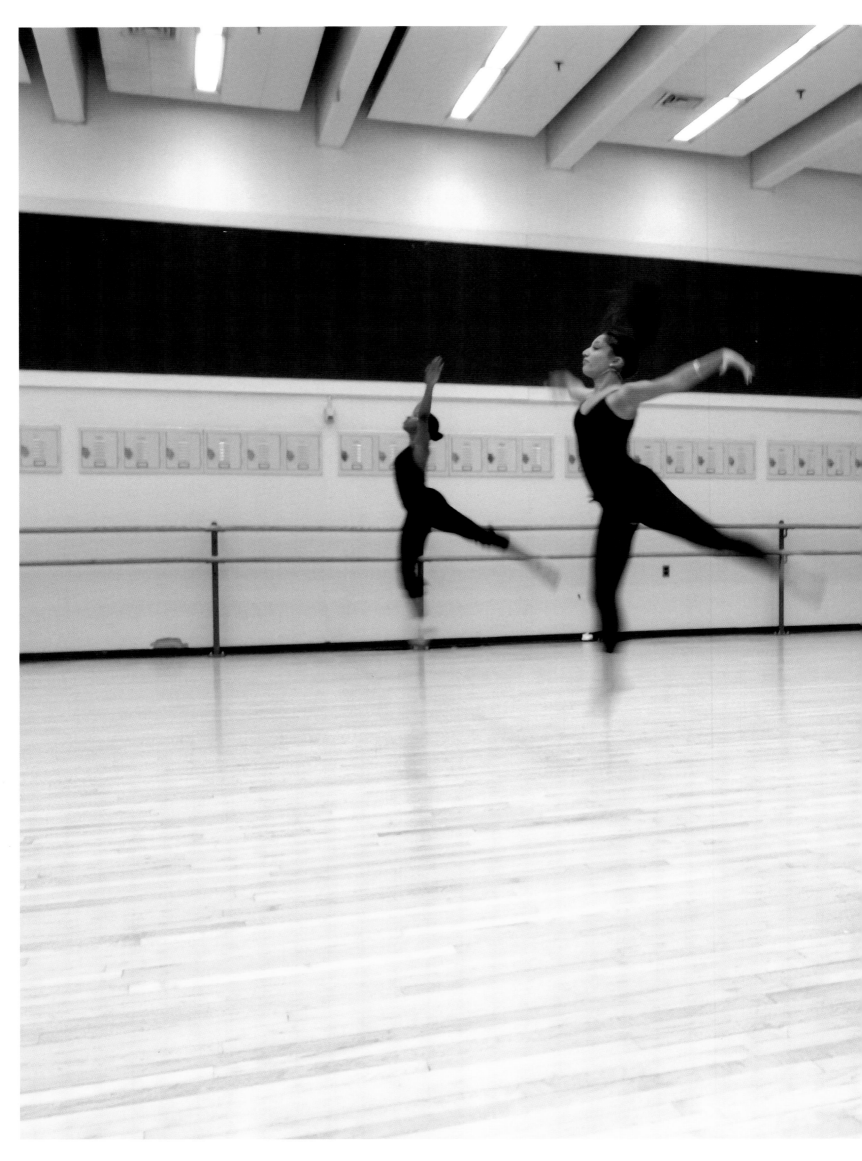

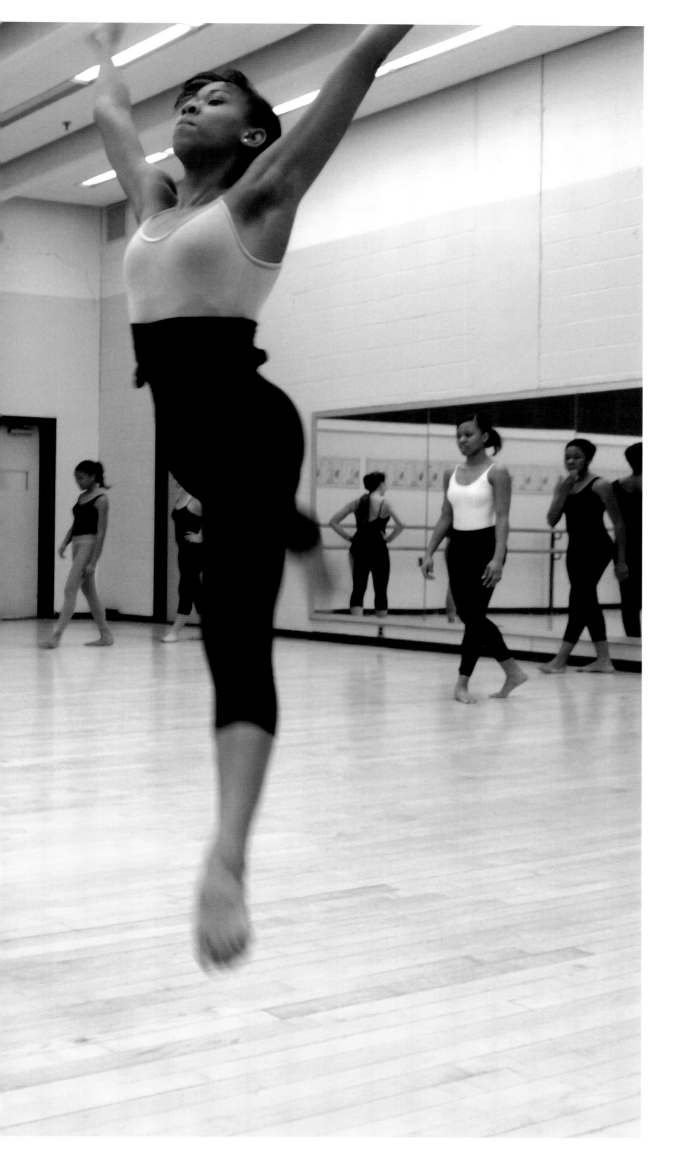

52 LaGuardia was one of the most important influences in my life.

I hope the current students realize how fortunate they are and that they grasp all of the opportunities afforded them.

Norman Walker, Alum, Choreographer,
Associate Professor of Dance at Butler University

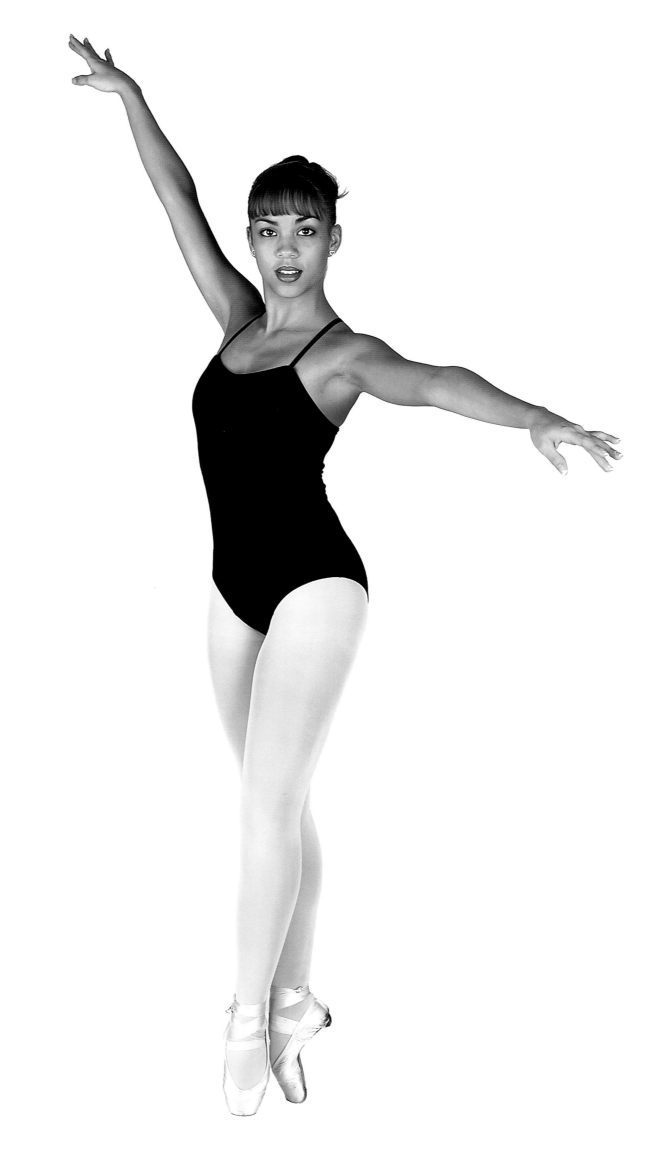

I wish I had a sharper memory.

I began teaching at Performing Arts High School when Elizabeth Rockwell was the dance chair. We were in a very old building but it had character. It was in a rather seedy part of the theater district but because of its quirks, it had charm.

My most vivid memory is of how intimidating the students were to me. The girls came to class made up to the hilt and showed great superficial sophistication; the earrings dangled and the finger-nails gleamed. At the time, dance education was still in its infancy so most students thought only of going into show business.

Ethel Winter, Instructor, Founding Member of the Martha Graham Dance Company

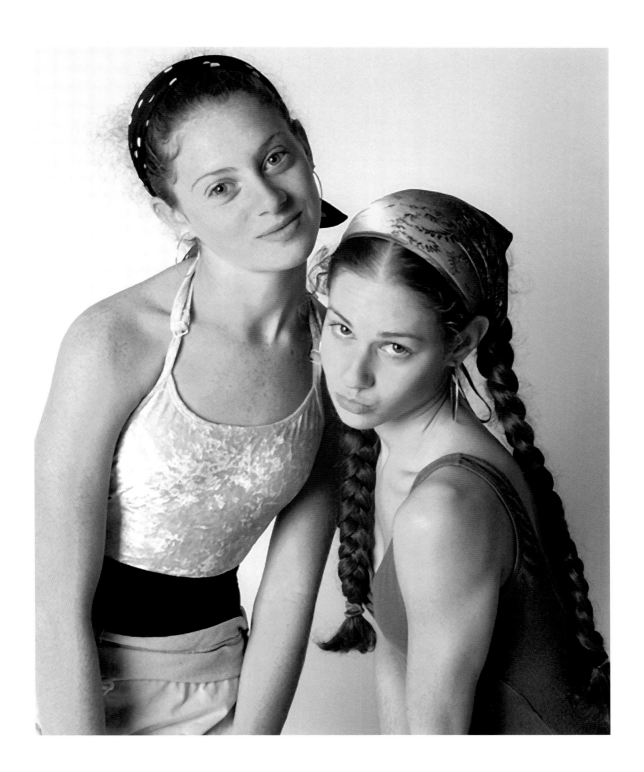

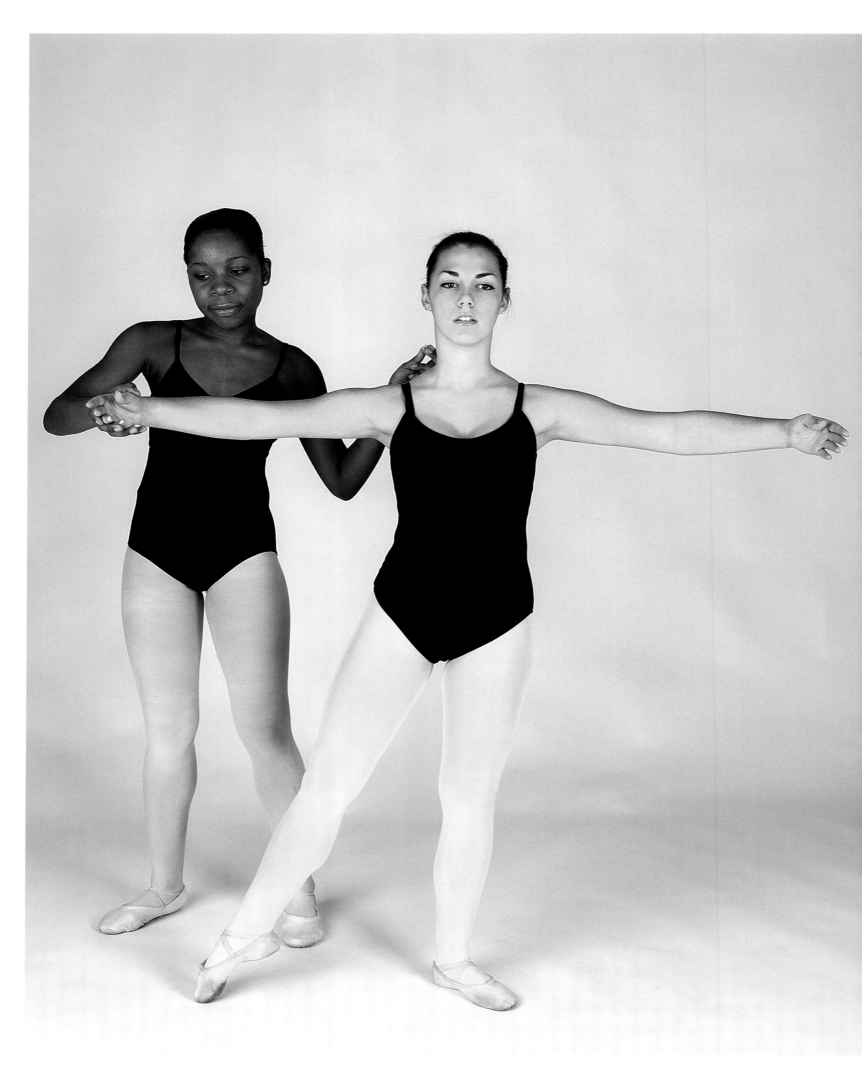

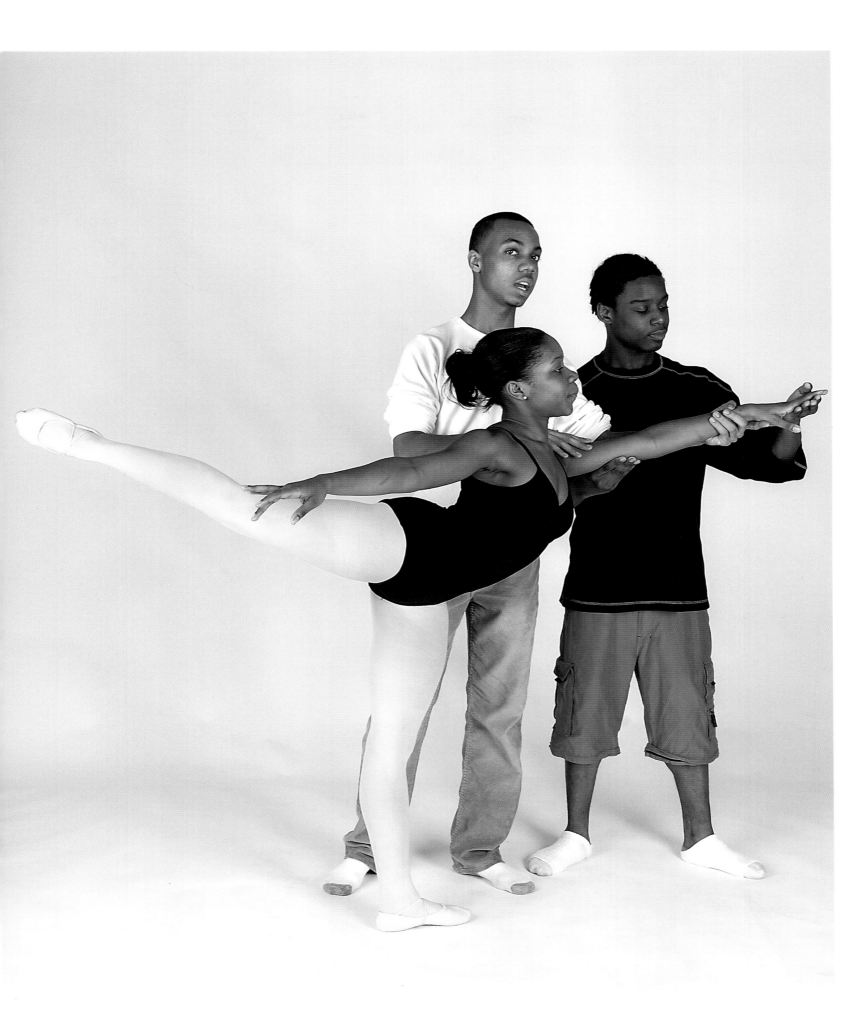

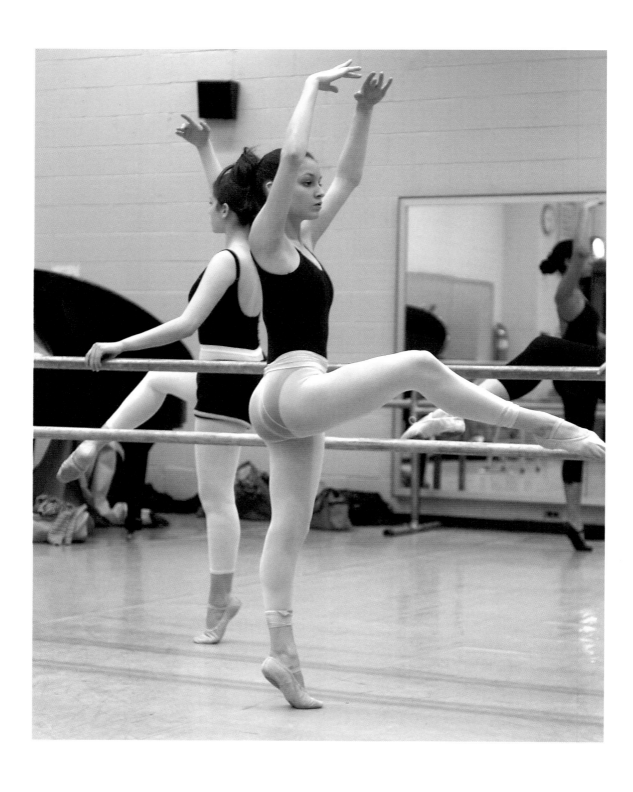

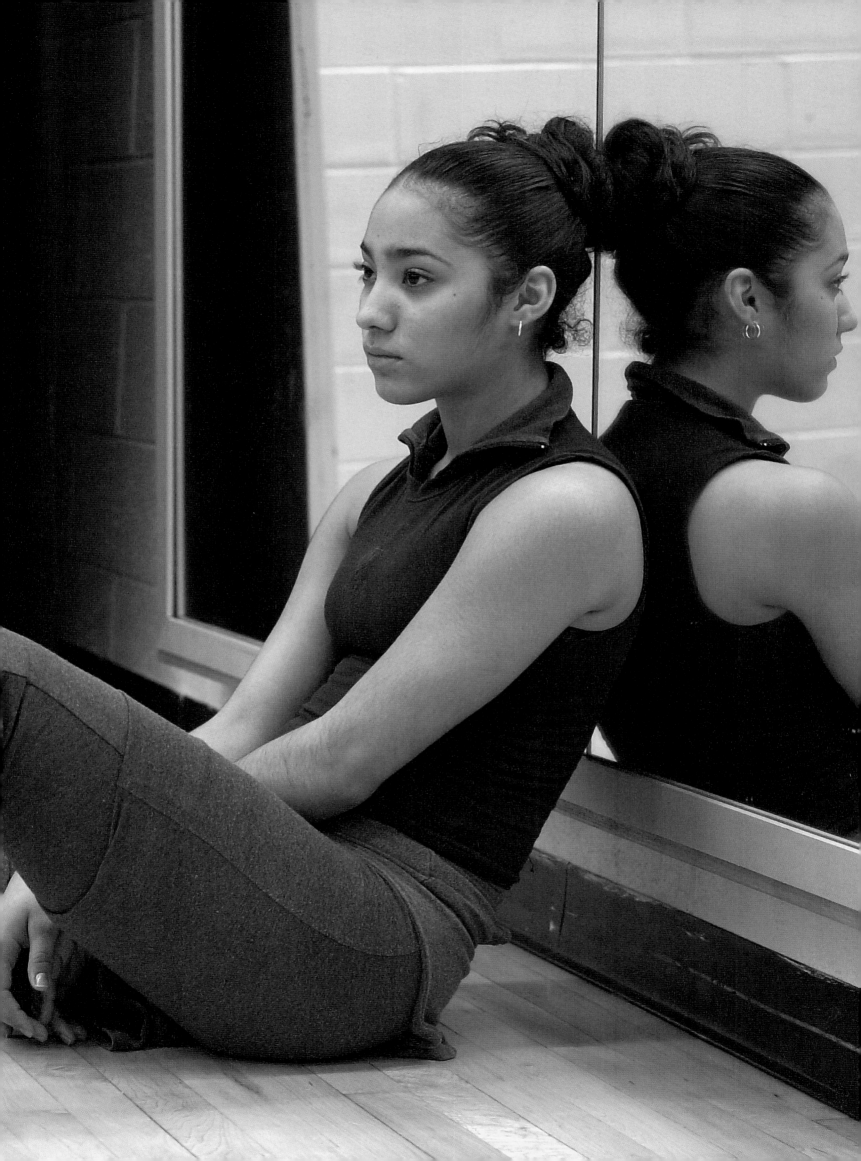

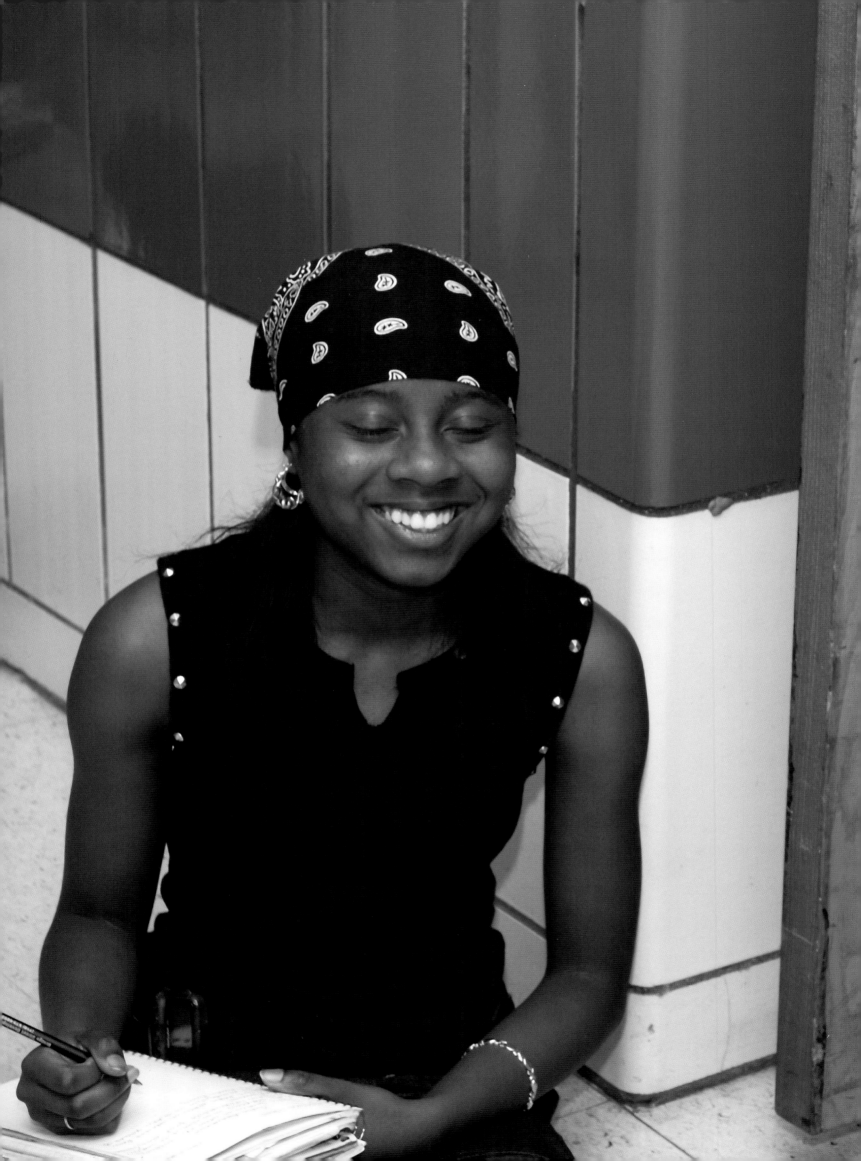

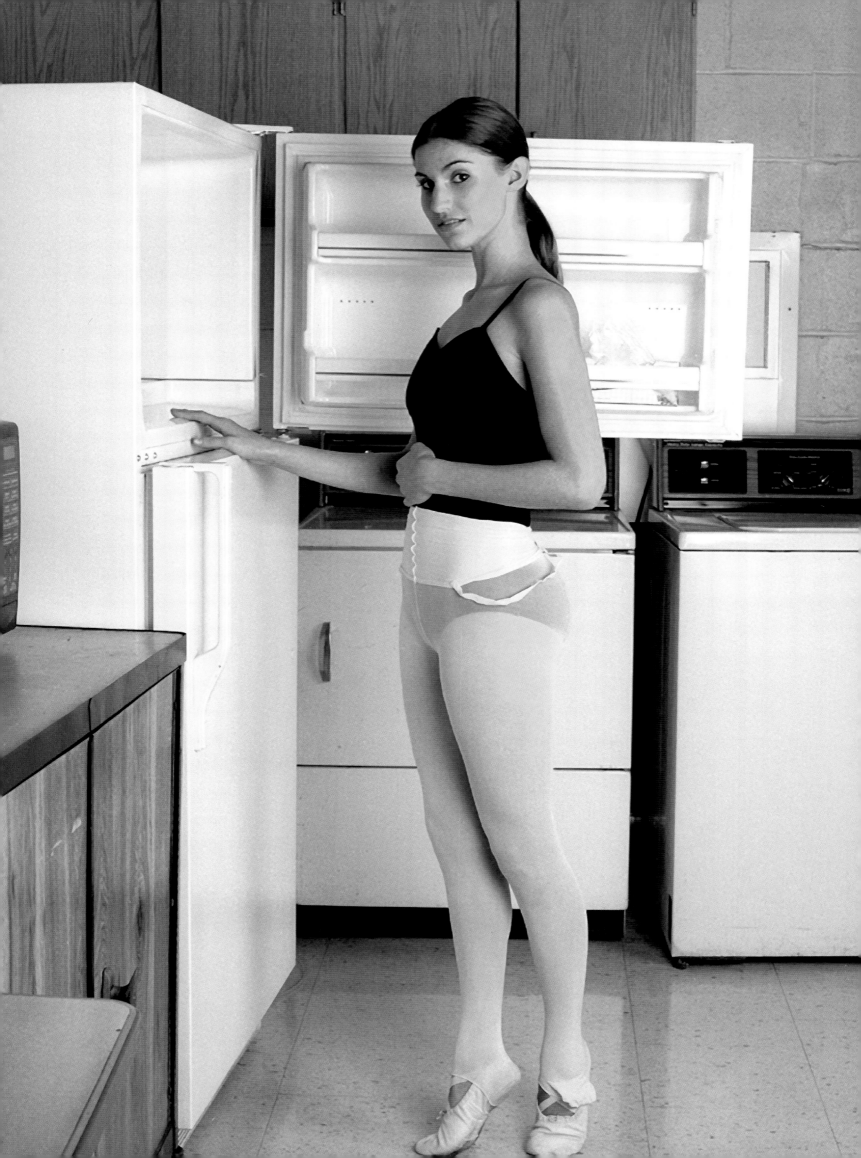

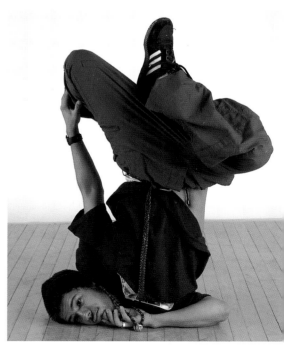

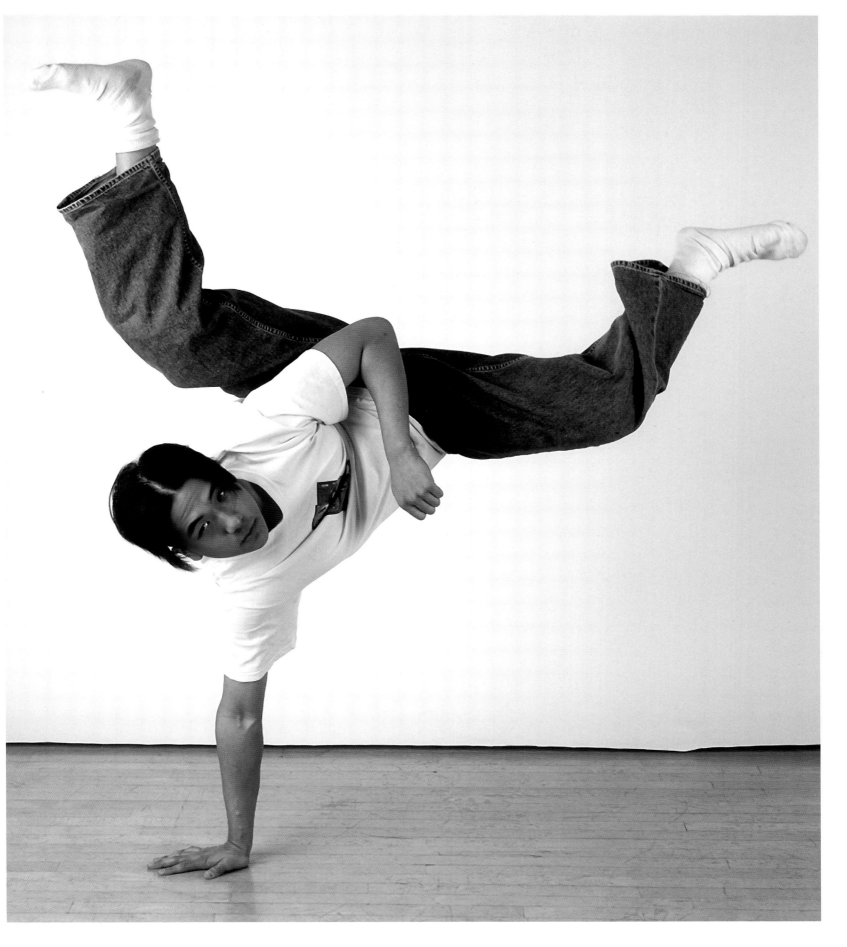

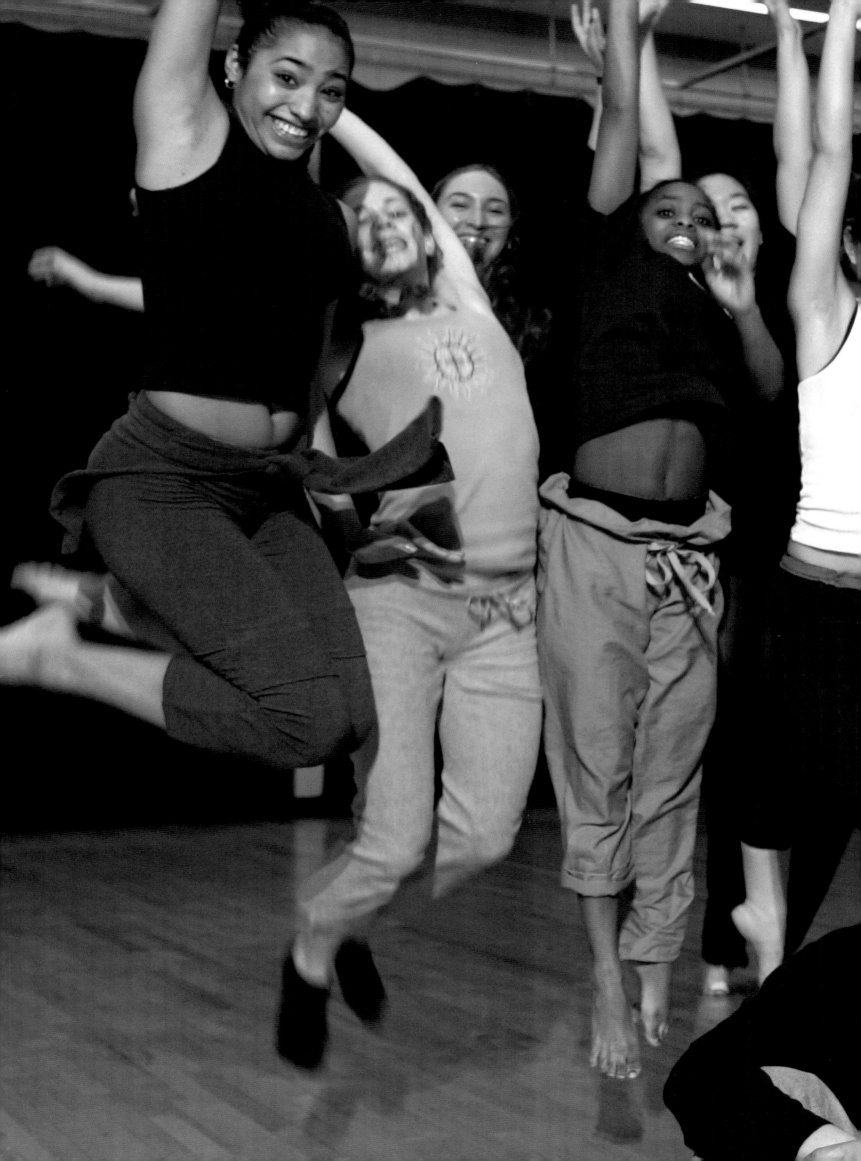

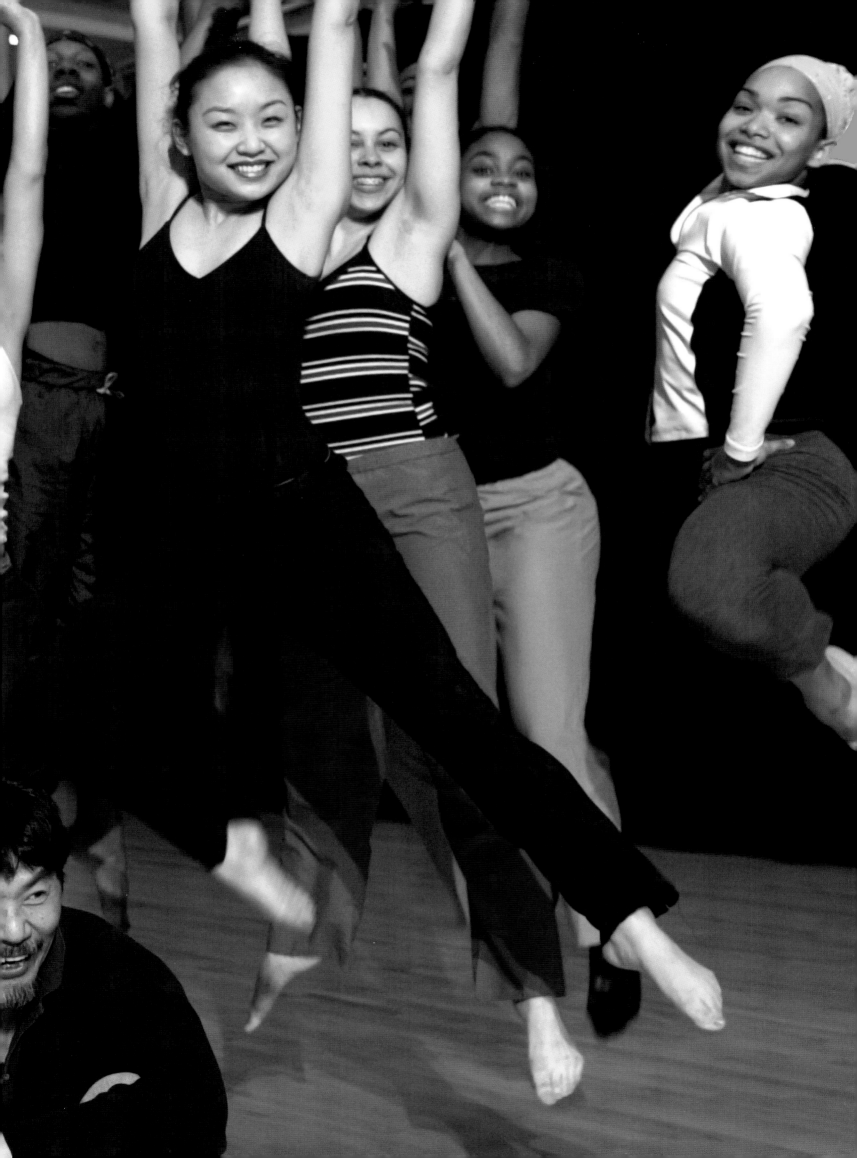

68 At LaGuardia I came into my own as a dancer.

Camille A. Brown, Alum;
Ronald K. Brown's Company, Evidence

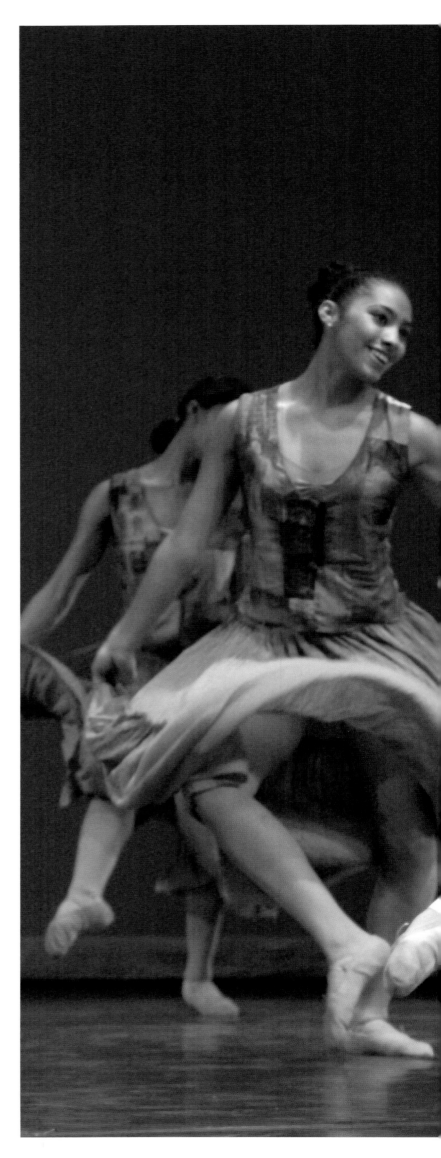

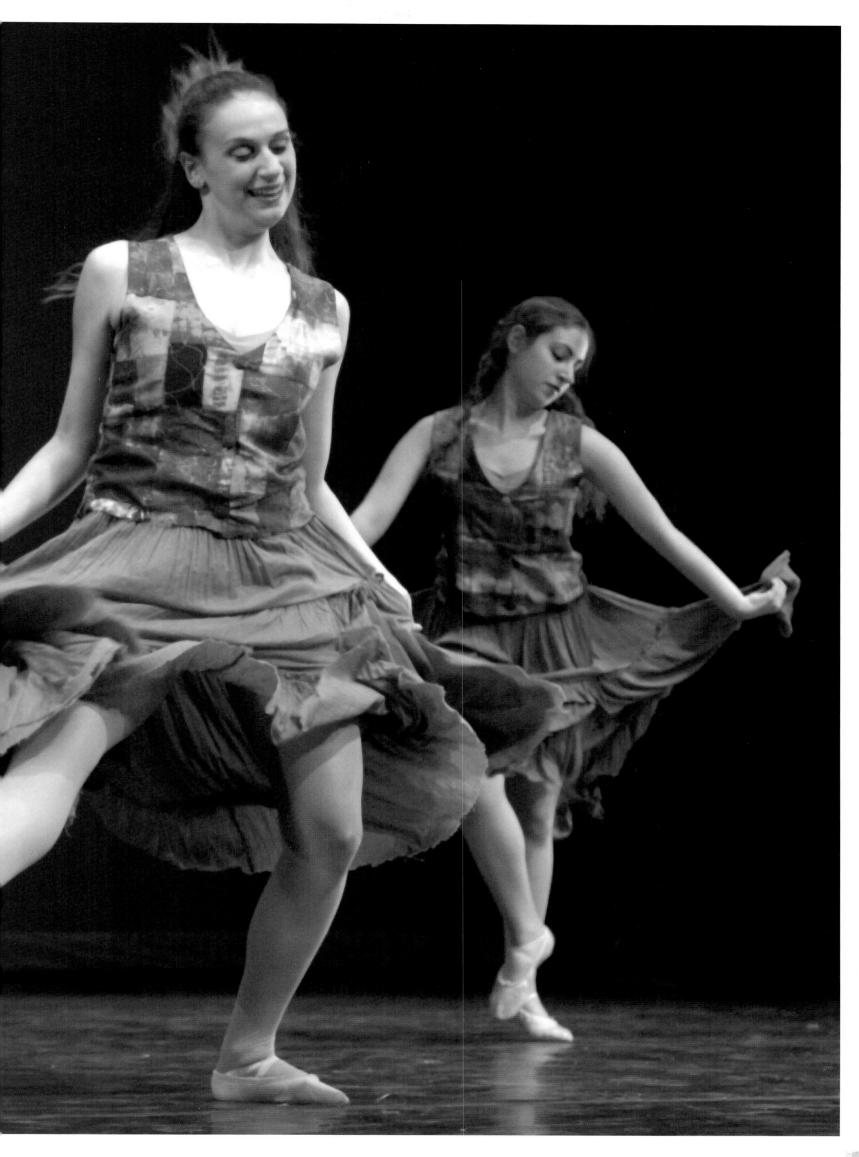

Training with the likes of Norman Walker, Gertrude Shurr, Stephanie Zimmerman, Louis Falco, May O'Donnell, Chuck Davis and Matteo, established a highly professional standard that enabled me to find instant employment upon graduation. The well-rounded curriculum gave me an edge in versatility and professional marketability.

Susan McLain, Alum;
Former Principal for the Martha Graham Dance Company

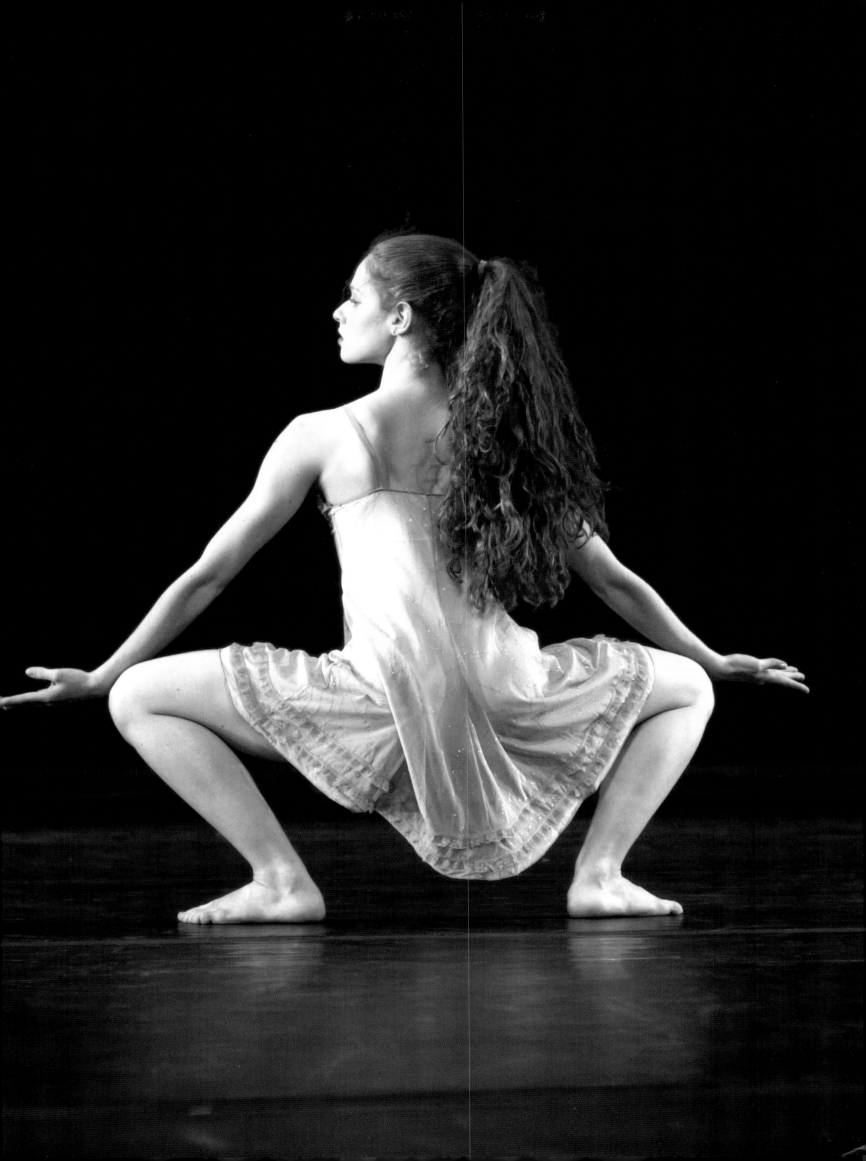

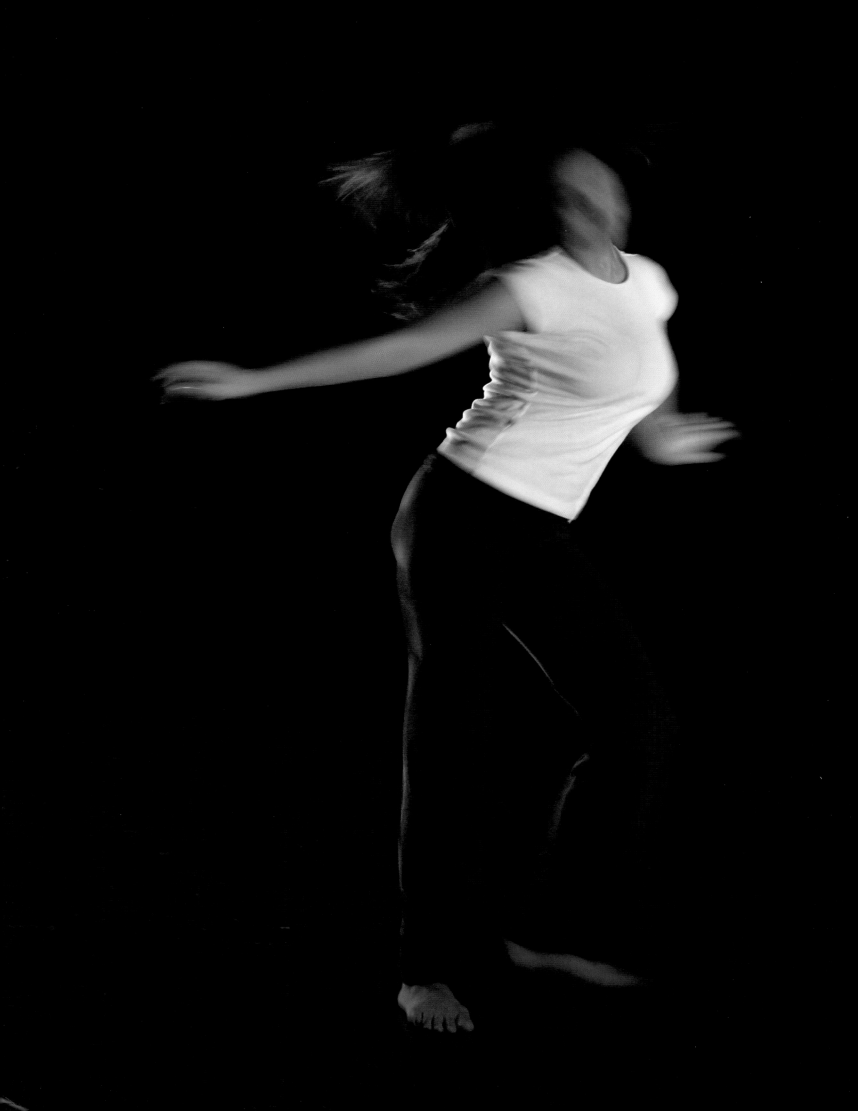

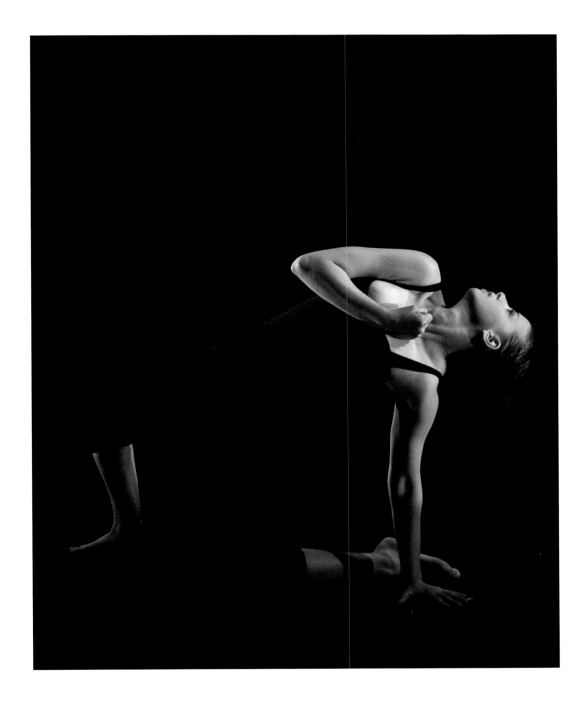

I did not attend the High School for Performing
Arts; my younger sister did. While she was there,
I performed at the school as a professional dancer.
Had the school been around for my high school years,
I would have been the first in line.

Tina Ramirez, Artistic Director, Ballet Hispanico

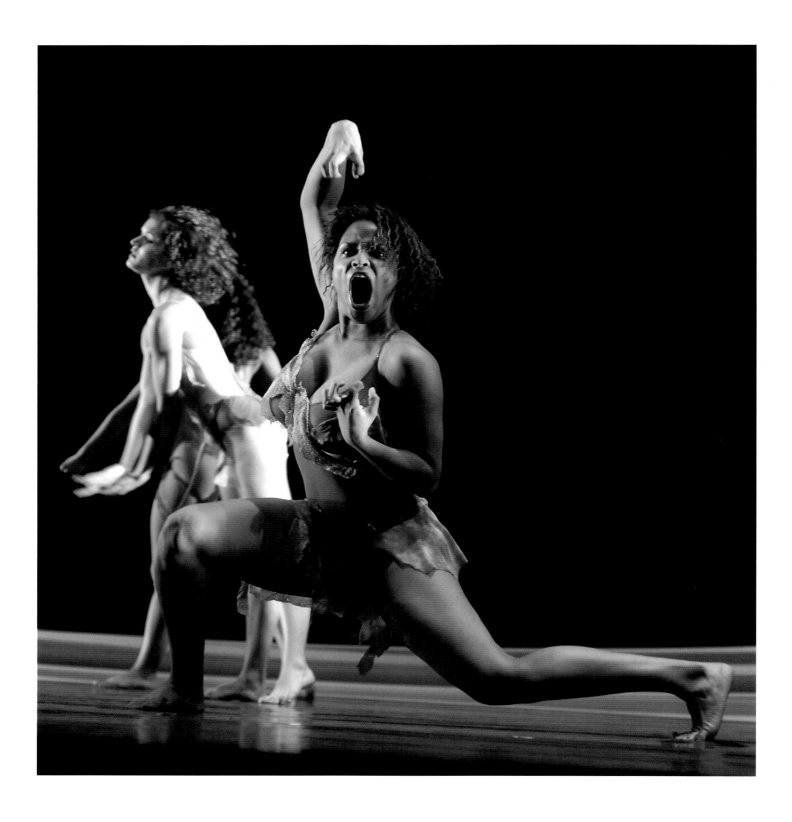

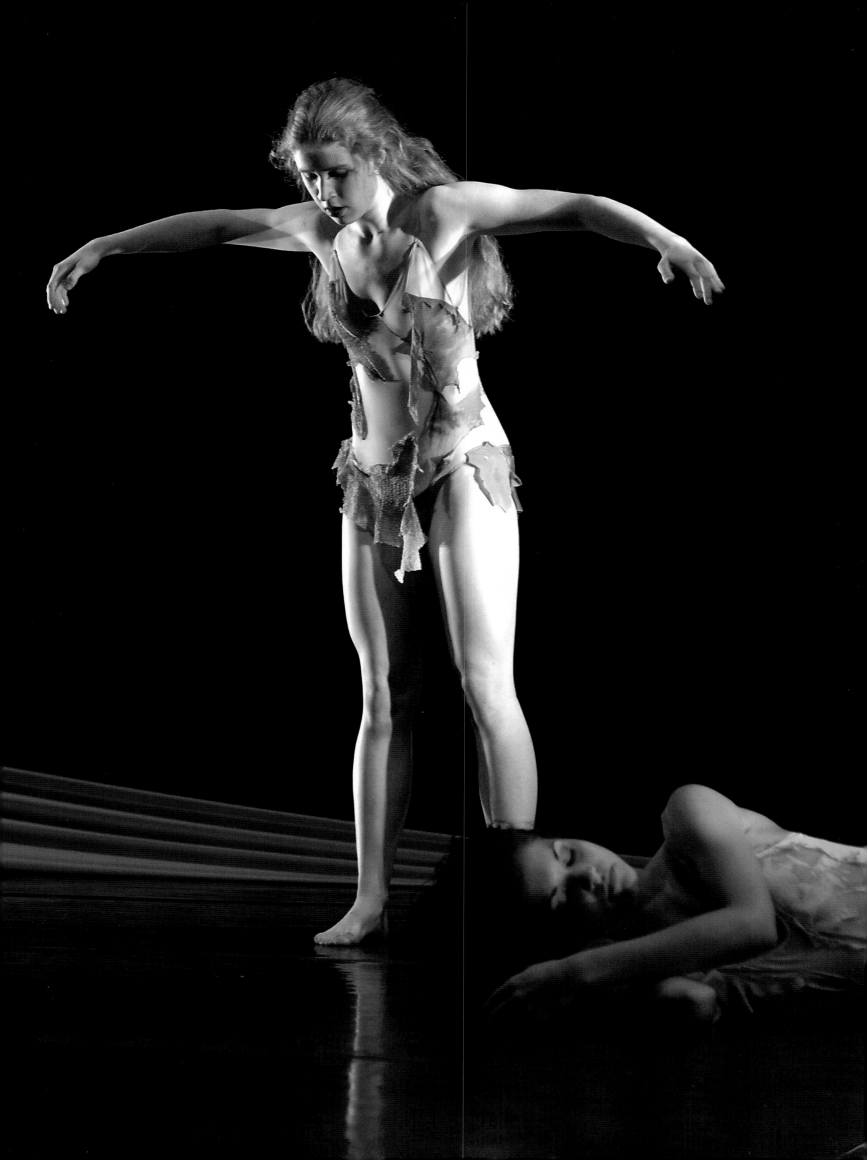

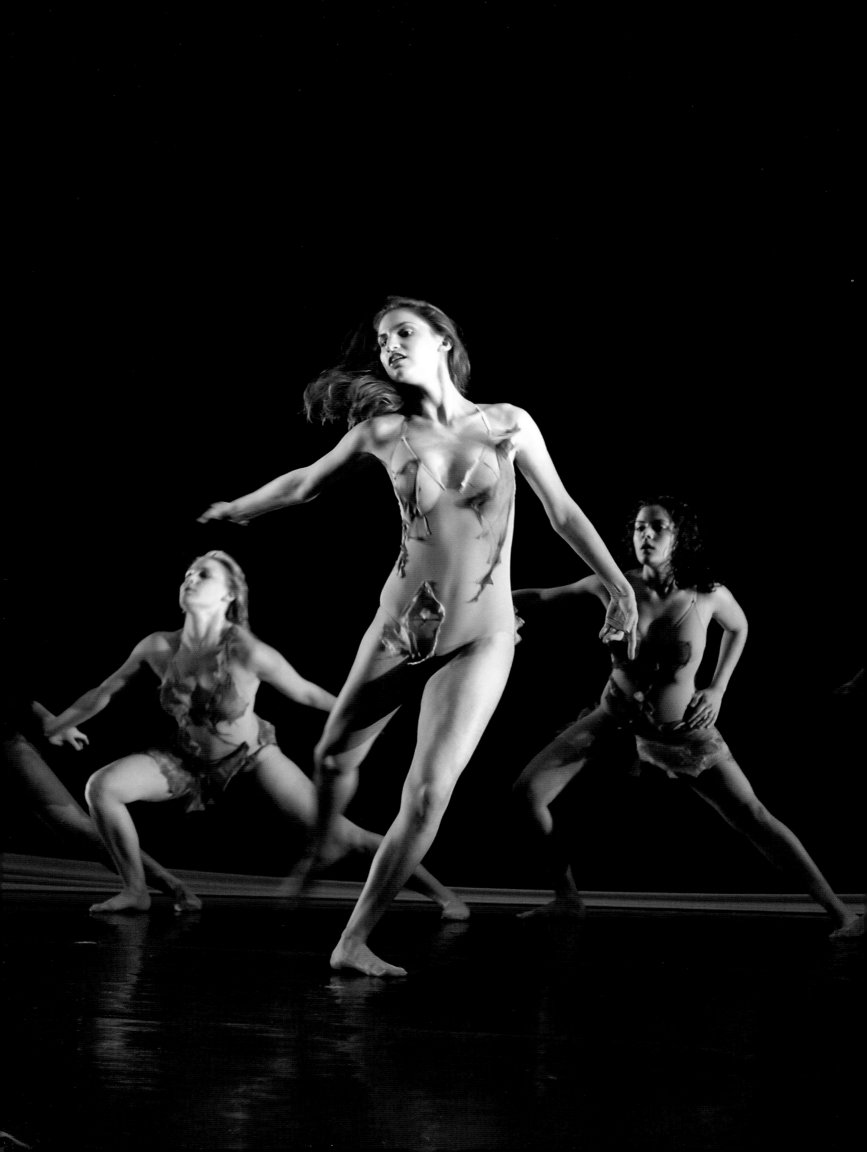

Back in Ohio we wore formless green rompers
to the woefully pitiful gymnastics class that was
offered in my high school.

When I began teaching at Performing Arts, I
thought about the vast difference between my high
school experience and that of my students. Those
talented youngsters were being given such a high
level of instruction.

Marian Horosko, Past Instructor; Former Member of the
New York City Ballet and Author of several books on dance

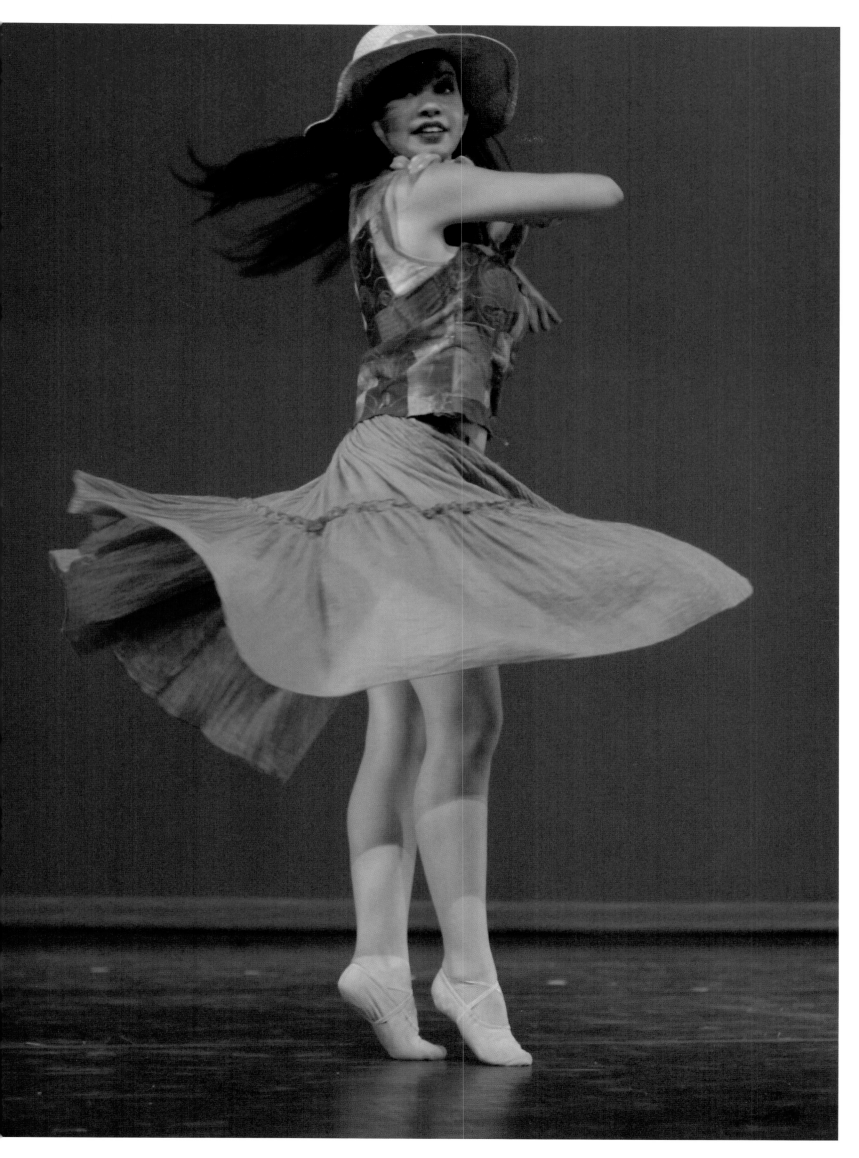

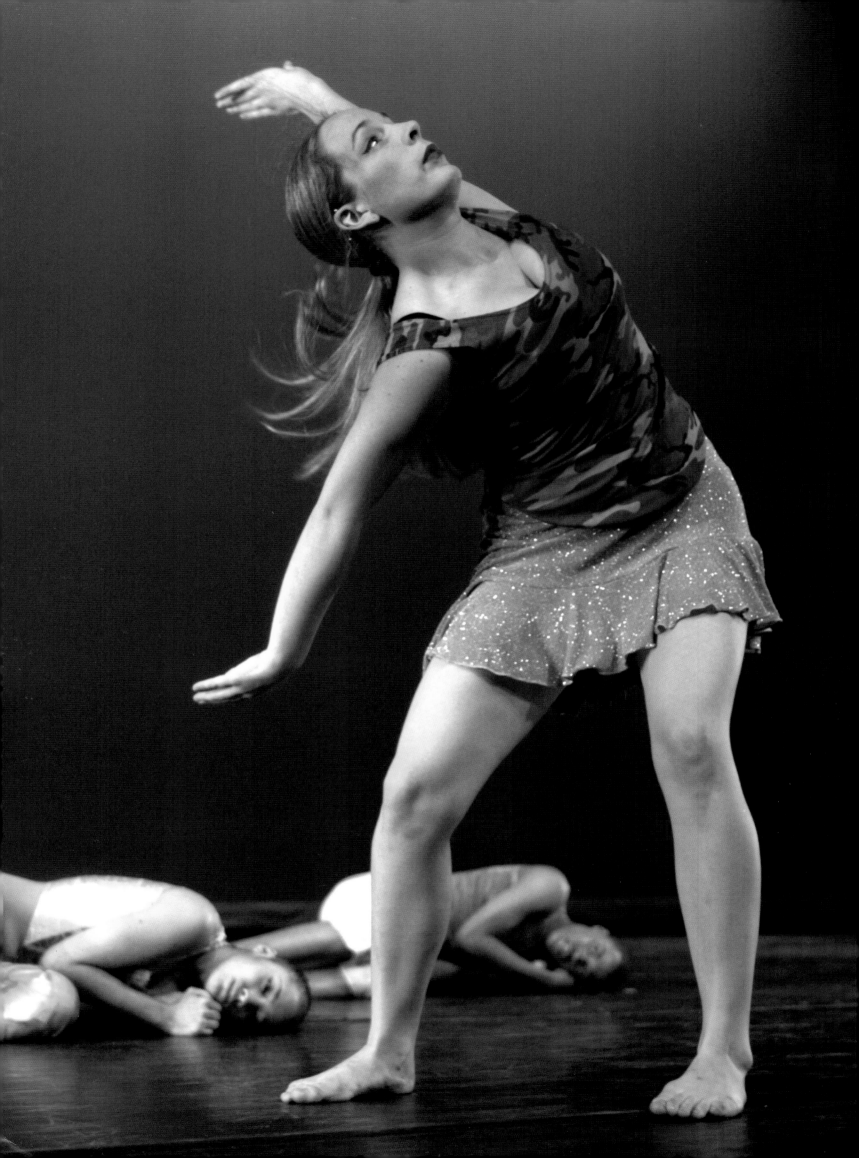

Dance in America has been enriched by LaGuardia.
It brings young people to the art that otherwise
may not have had the means or opportunity.

May O'Donnell, Past Instructor; Founder of
the May O'Donnell Dance Company

I almost didn't get accepted to LaGuardia's Dance Department; I had to audition three times. I guess they couldn't decide because I had no dance training at all. I improvised my way through the whole audition, as I had been doing for years.

I thrived in this wonderful school. Thanks to dedicated teachers who encouraged my talent and hard work, I went on to dance as soloist in the Joffrey Ballet, London Festival Ballet, Ballet de Luis Fuente in Madrid and other companies in Spain and the United States.

After a long and fruitful career as a dancer, I now teach ballet. I try to give my students the same encouragement and support that was given to me.

Zelma Bustillo, Alum; School Artistic Director of Ballet Hispanico

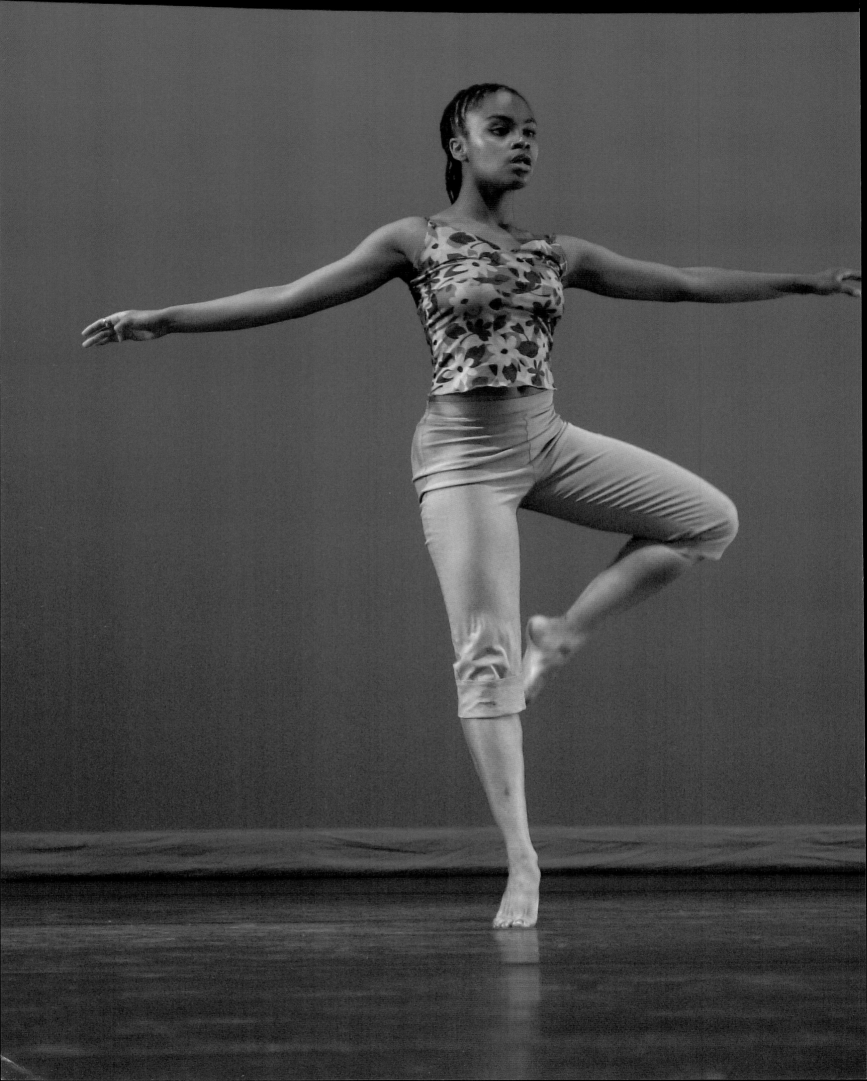

At the High School for the Performing Arts the faculty was a young dancer's fantasy. People such as Robert Joffrey, Mary Hinkson, Uta Hagen and Vinette Carroll were to have a hand in molding my future. And my classmates, Dudley Williams, Michael Kahn, Susan Strassberg and many others helped me focus my creativity as I made my way through those four exhilarating years. Occupying a special place in my memory is Nancy Lang who taught me how to explore myself through art.

Eleo Pomare, Alum; Instructor; Choreographer;
the Dayton Contemporary Dance Company;
Founder of the Eleo Pomare Dance Company

Performing Arts demanded that students be thorough, well trained and disciplined in one's craft. On those bedrock values, inspiration is free to soar.

Matthew Diamond, Alum; Director of The Golden Girls; *filmmaker of the Oscar-nominated documentary* Dancemaker

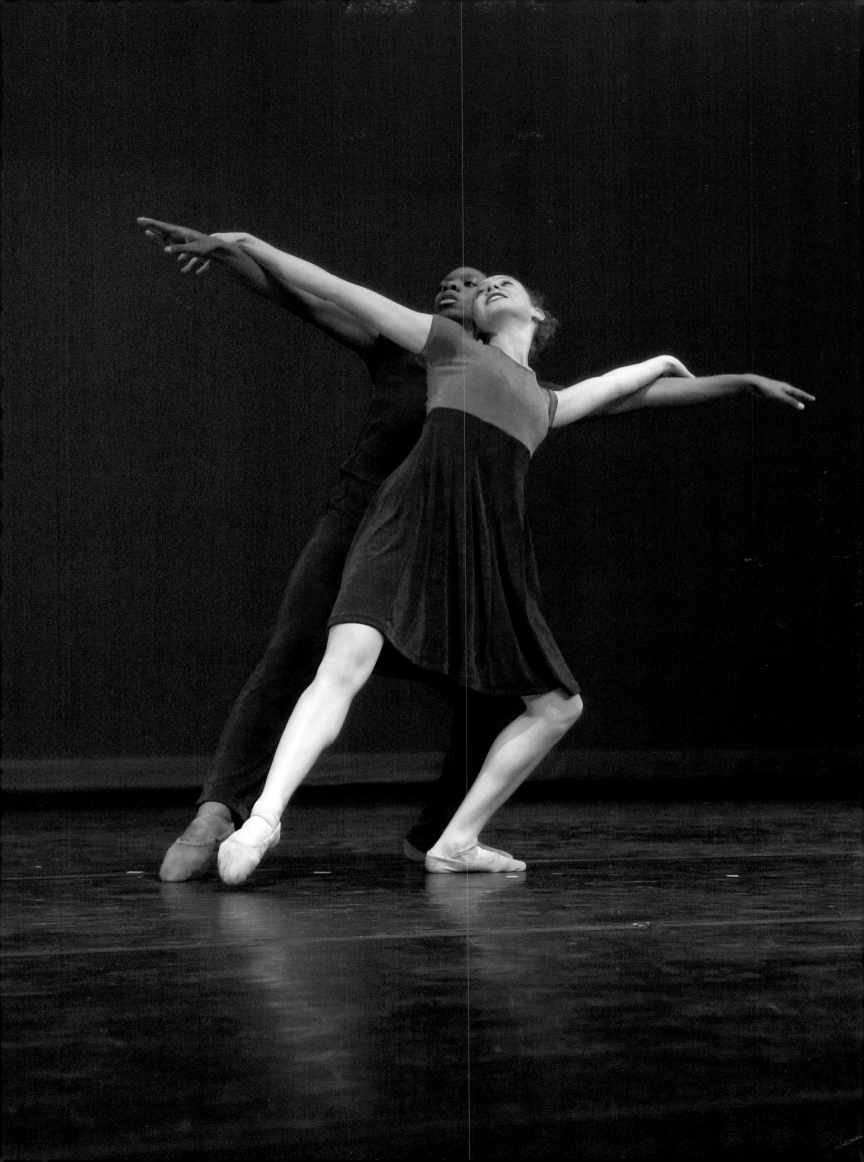

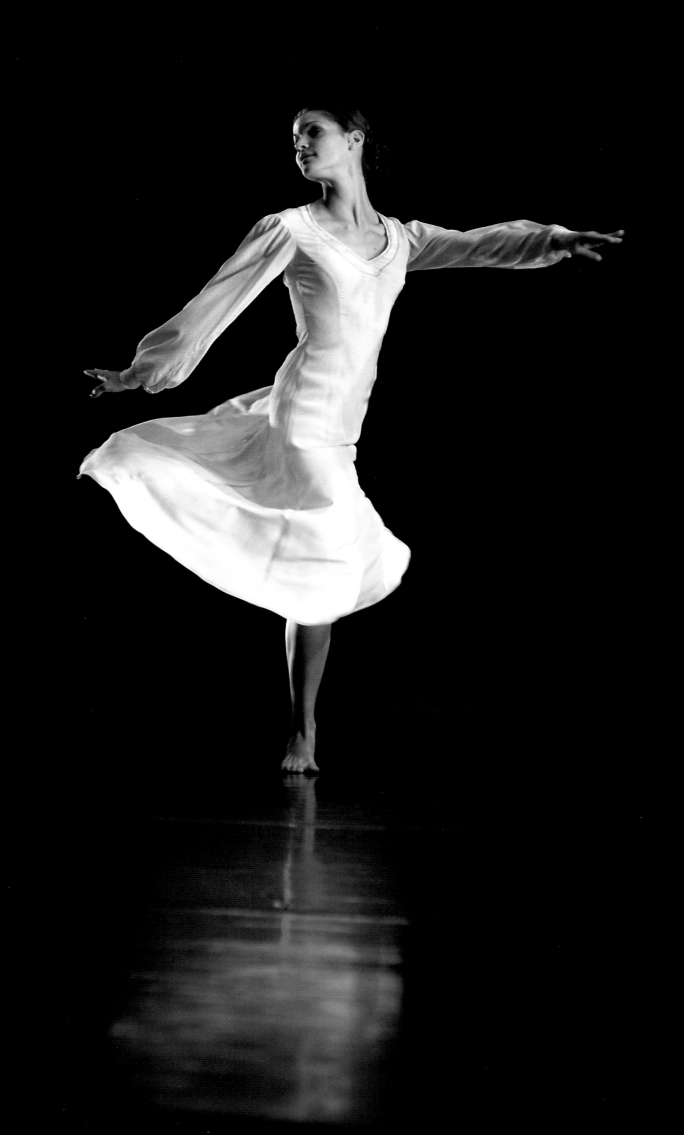

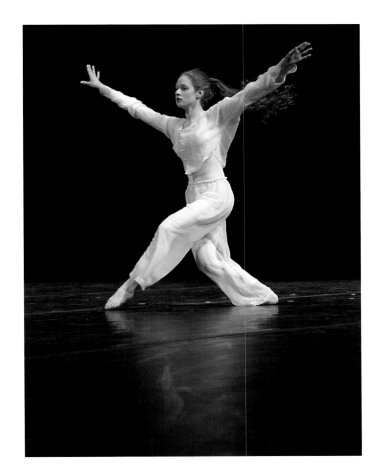

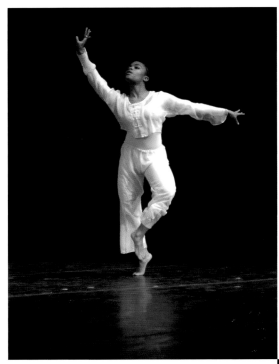

LaGuardia has become my second home as a
choreographer. I've created several new works
for the Dance Department, and each has been
a surprise.

There is always a feeling of anticipation and
discovery when working here. It's an exciting process.

H.T. Chen, Artistic Director, H.T. Chen & Dancers

90

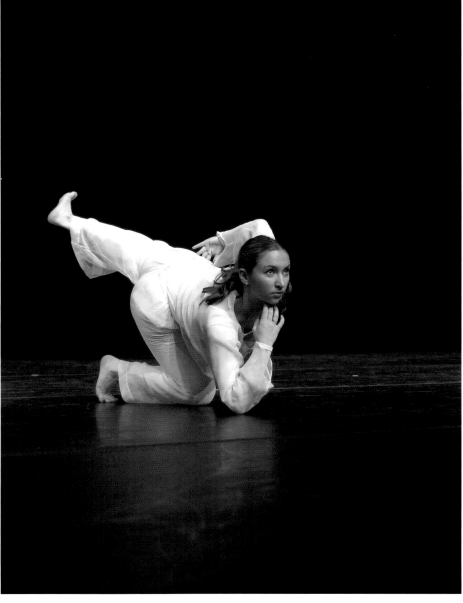

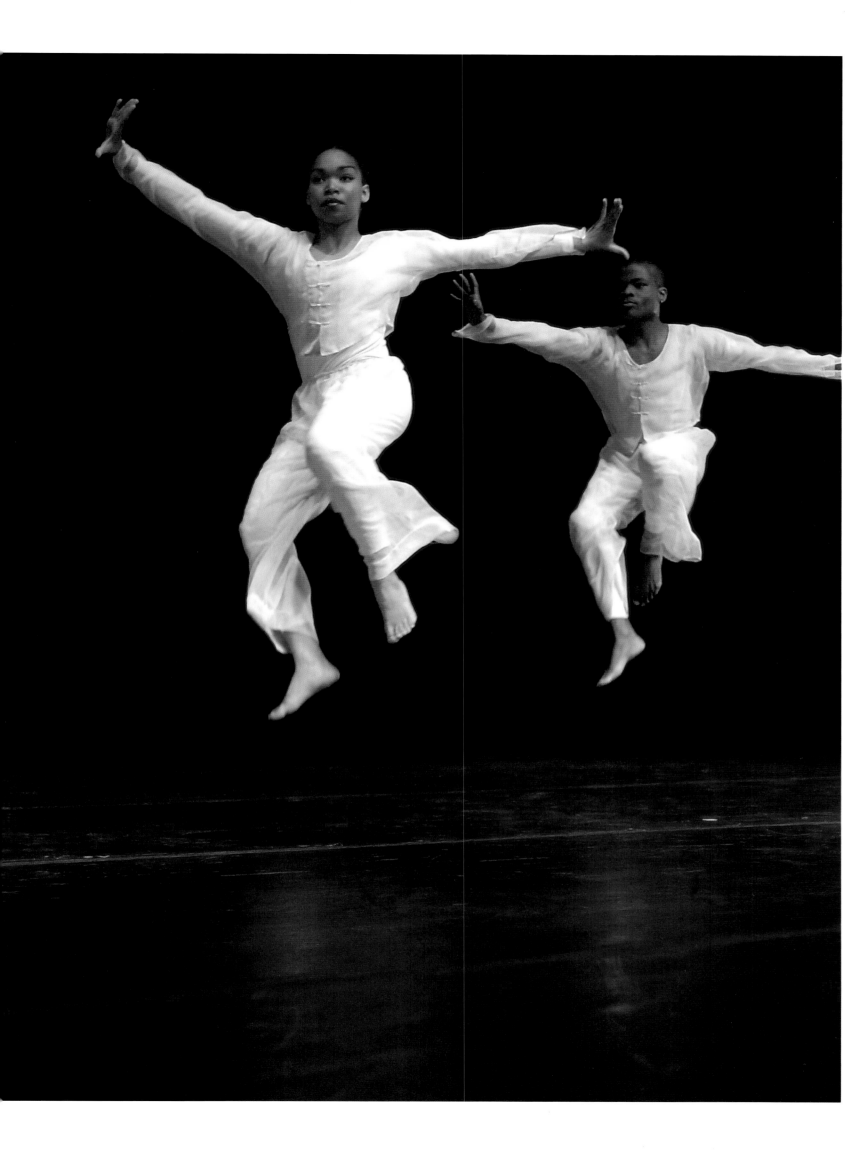

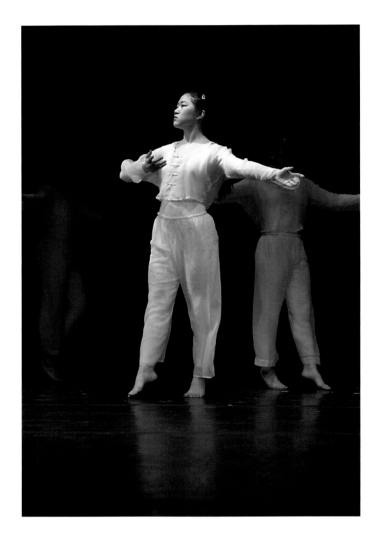

LaGuardia is one of those rare gems in the city of New York. A public school with a dance division, with so much talent, dedication and excellent guidance is a great thing.

Darrell G. Moultrie, Alum; currently performing on Broadway in Elton John and Tim Rice's Aida

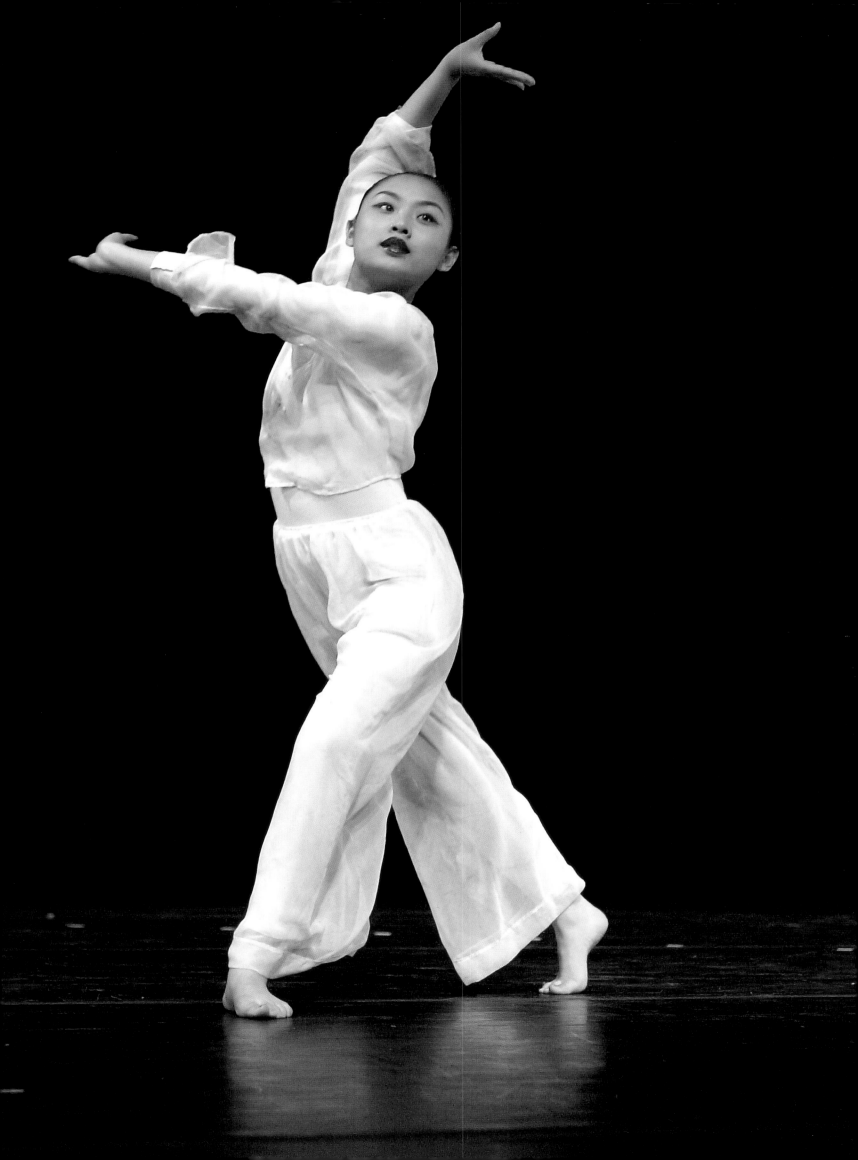

The years that I spent in the dance department were the most valuable and influential of my entire life.

The faculty and students supported my novice dance potential so that by graduation I not only entered the Juilliard School on a scholarship, but also landed my first Broadway role as a dancer in *The Wiz*. Not bad for a girl with only one year of African Dance prior to freshman year.

The school transformed my life. In return, I hope I have inspired the lives of those around me.

Krystal Hall-Glass, Alum; Dance Director, Harlem School of the Arts

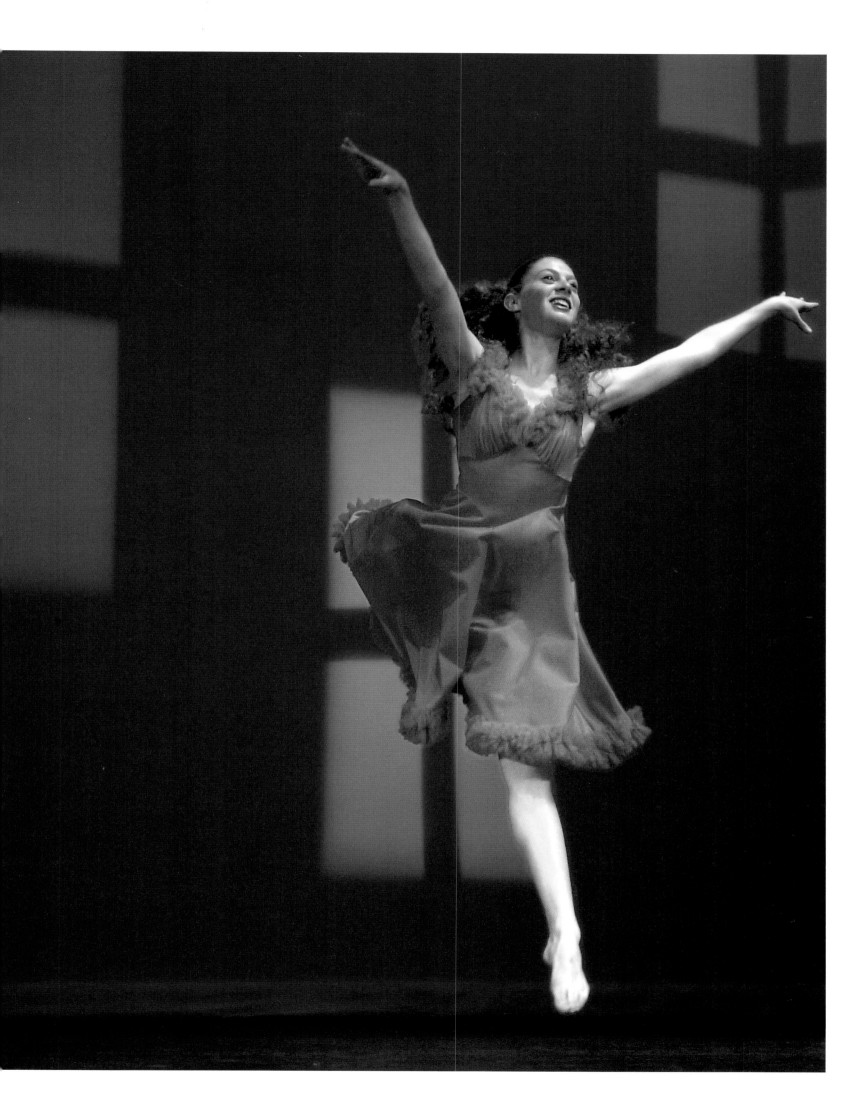

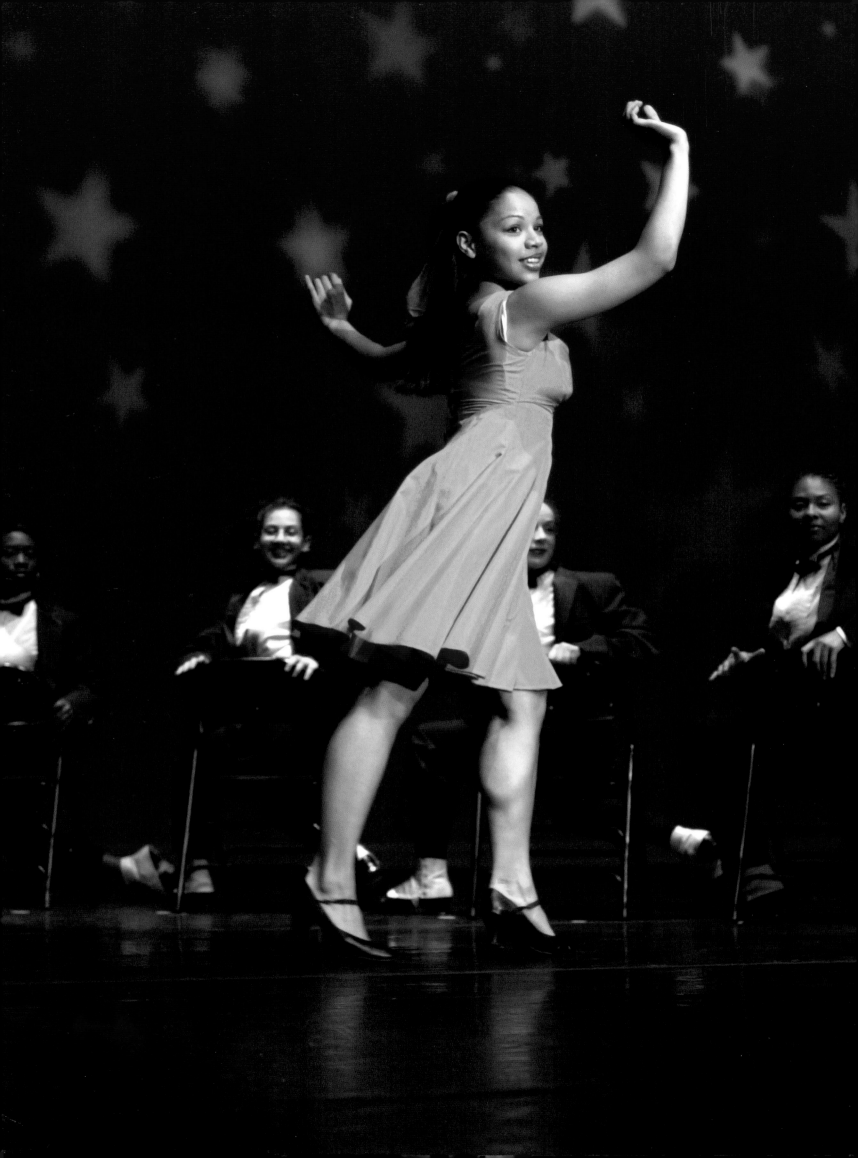

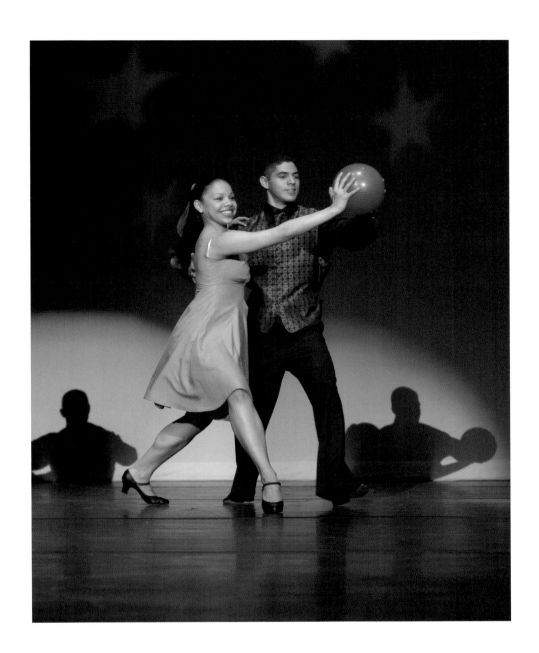

LaGuardia's one hundred percent belief in me is
the main reason I am still dancing.

Luis Rodriguez, Alum;
National Theater Mannheim, Germany

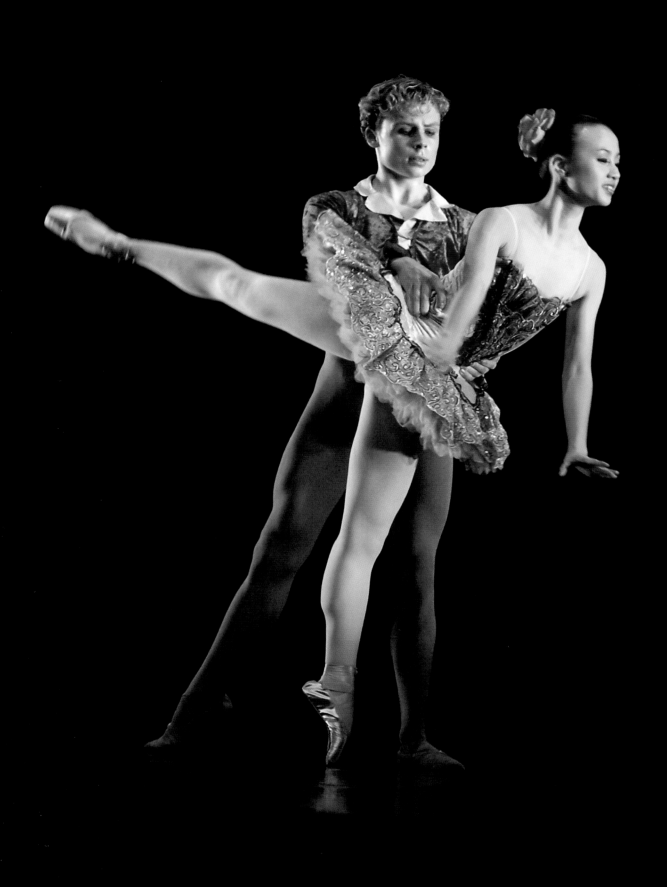

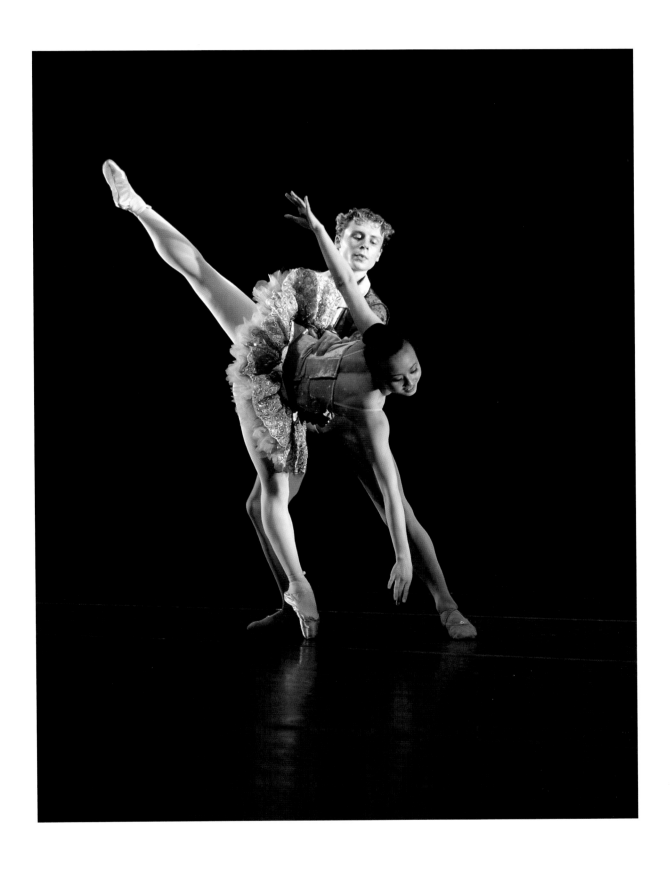

It has been more than seventeen years since I graduated from the old Performing Arts School. The love and support that I received there has allowed me to achieve goals I never would have dreamed possible.

The school has motivated me to be bigger than I am.

Jean Émile, Alum; Netherlands Dance Theatre

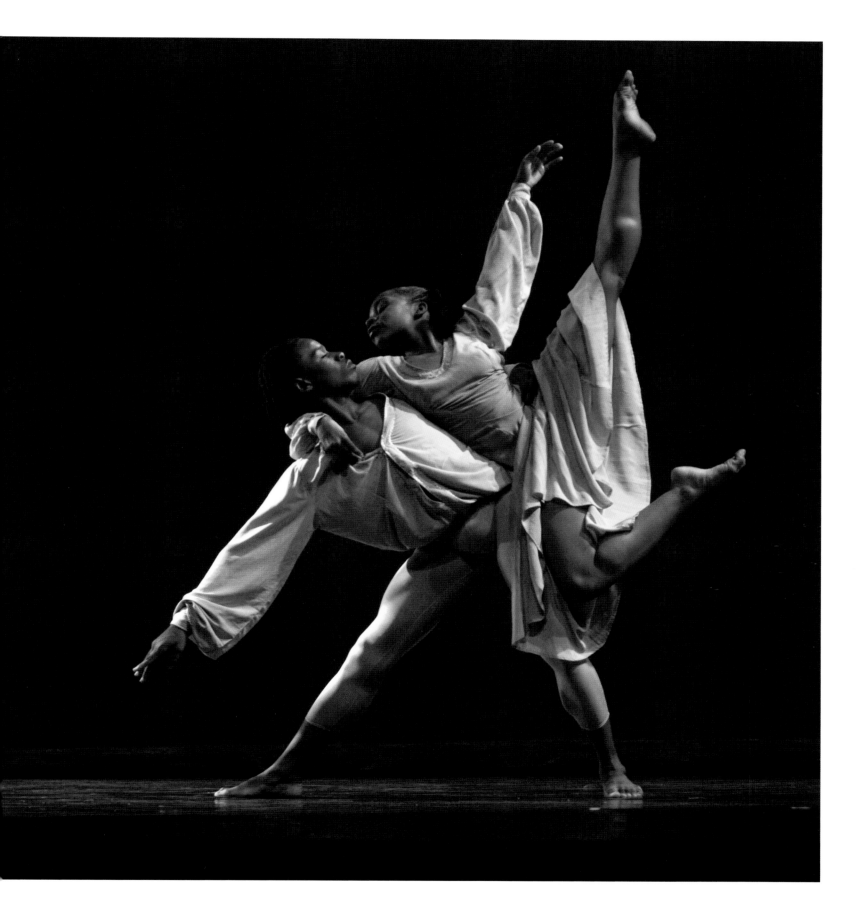

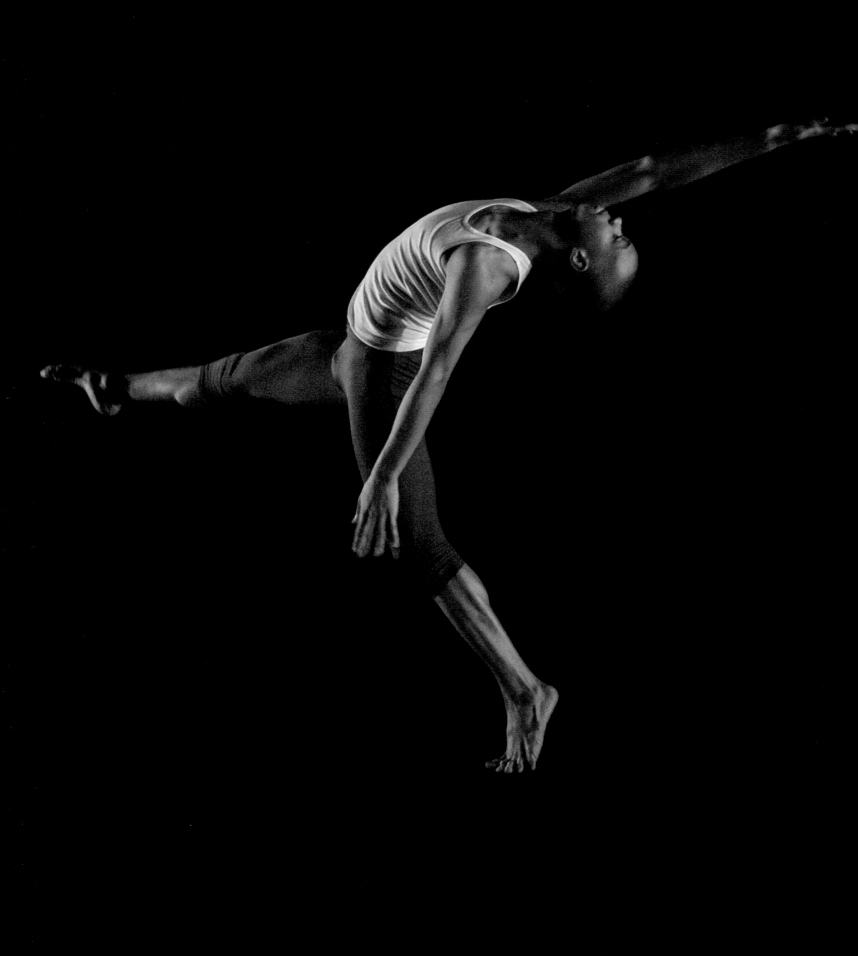

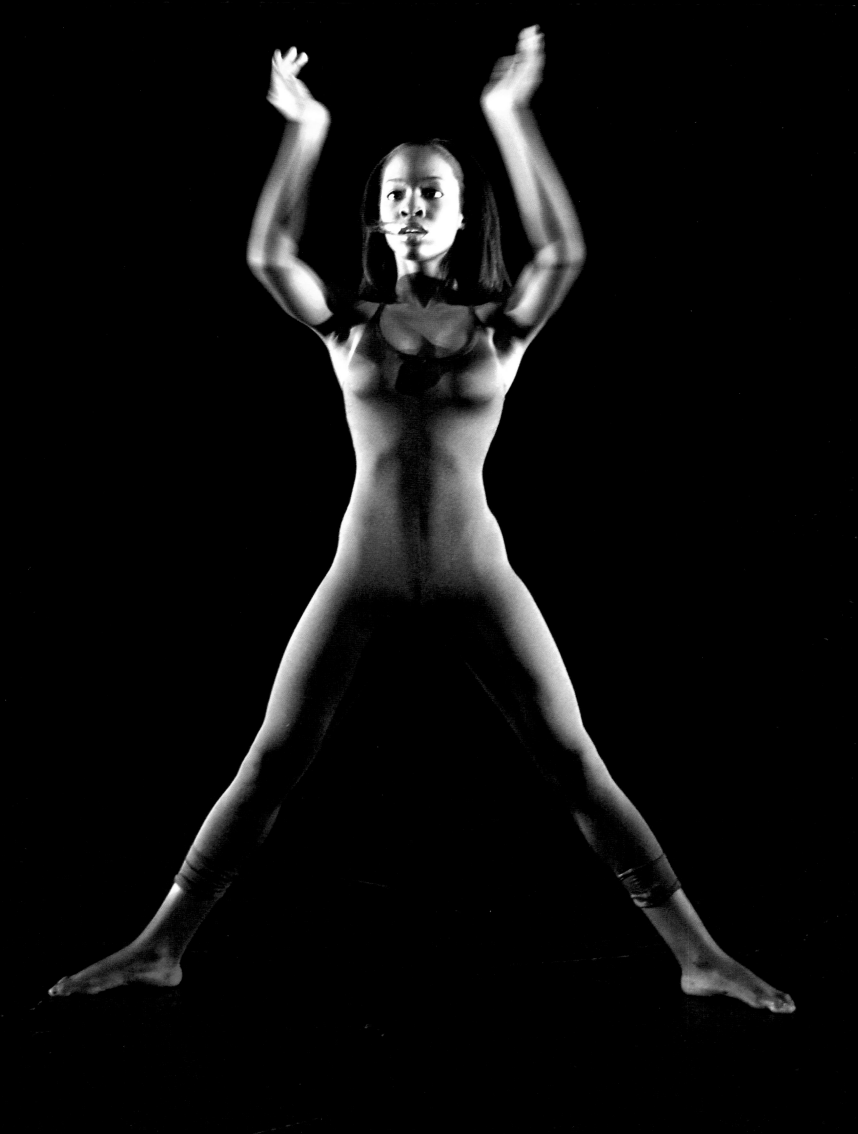

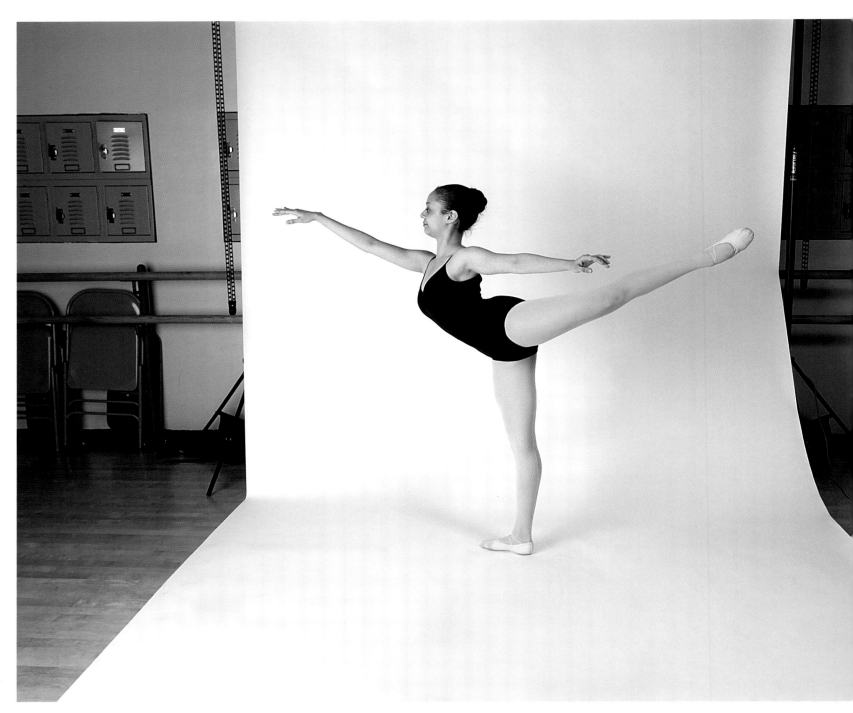

Barbara Miller

AFTERWORD:
PHOTOGRAPHER'S JOURNAL

Kristel Sterbenz

All of these photos, all of the effort and expense I've contributed to these dancers and the school gives me a lot of satisfaction. This new career is one of the most exciting things I've done in my life.

Here's my recollection of a particularly eventful week.

"Every time I see that picture it makes me smile," Mickey said. I'd use that photo of Kristel to print 150 posters for their February Dance Showcase and then I'd follow the posters to New York. The Showcase would be fun and I could shoot the rehearsals.

Once back at the school, Mickey suggested I go to the Buglisi/Foreman dress rehearsal at the Joyce Theater, starting in just half an hour. The school's publicist, Audrey Ross, had a ticket to the opening night performance, which Mickey couldn't use. She passed it to me. Coincidentally, I had tickets for later in the week, so I knew of the performance.

I'm the eighth photographer at rehearsals, the last one to arrive. The rehearsal is already underway. I fumble in the dark to set up the tripod, the laptop and the camera.

As has happened before, the setup attracts attention. In the darkened theater the laptop glows with images as I shoot. I snap a few pictures and stoop to see that I'm getting the shot. As the dance winds up and the house lights brighten, a few of the curious types approach.

Soon the rehearsal is over; I know I have some good shots. The adrenaline rush is back.

Back at the print shop I use as my living quarters, things are humming as I begin to review the photos. But for some reason the images appear upside down in the computer. There are many false starts as I spot one with potential, turning it to confirm the decision. Then, near the end of the second dance, there's the shot: a lone dancer

with the stage bathed in light, as if sunlight were passing through a stained-glass window. It's got everything I want: color, drama and isolation. The confirmation for tomorrow night's performance sits on my desk. I copy a few details and in a minute I've got a poster. Twenty more and I've got it rolled up and I'm off to the theater.

Audrey is noticeably peeved when I arrive twenty minutes late, "You did know it was a seven-thirty show?"

"I thought this was worth waiting for," I shoot back and in a second I'm redeemed. The three ladies in the lobby are quite impressed; no one believes I shot it just four hours earlier.

I take my seat in a packed house. It's pitch black and my eyes aren't used to the dark. The usher enthusiastically greets me by name. I don't recognize her in the dark, but the phrase "from the school" connects. Thankfully, it's an aisle seat. I can relax.

In the program I discover that the poster shot is Virginie Mécène in *Requiem*. It's the world premier; a bit of good luck.

At intermission Audrey is happy to say that they love the poster. "Thrilled and amazed," she paraphrases. After the concert she introduces me all around.

The next morning at school, word has already gotten around. Mickey wants to know, "Is that the infamous poster from last night?" I proudly hang it up outside the Dance Department.

Then it's time to get back to headshots and the like. College deadlines have compressed and a handful of students need photos right away. I couldn't get a bite of food down this morning, so my batteries are draining fast. This work is slow: pose the dancer, snap the pictures, gather around the laptop, critique and, likely, re-shoot. The session drags on for hours. I'd promised to return to The Joyce again, there's a second program to rehearse. I'm tired when I arrive. I'll skip the laptop, no room for a tripod either, there's a violinist where I set up yesterday. I slink in and join the other photographers. I'll shoot handheld and take it a little easier. In an hour I'm too tired to do anything but pack up and head home.

Tonight's the night I have my own tickets. I've made four trips to the Joyce in two days. This is how the candle gets burned at both ends. After the show I head home knowing I've got hours of work ahead if I'm going to keep up with the workload at the school.

"Requiem," The Buglisi/Foreman Dance Company's Virginie Victoire Mécène at the Joyce Theater. Choreography © Jacqulyn Buglisi.

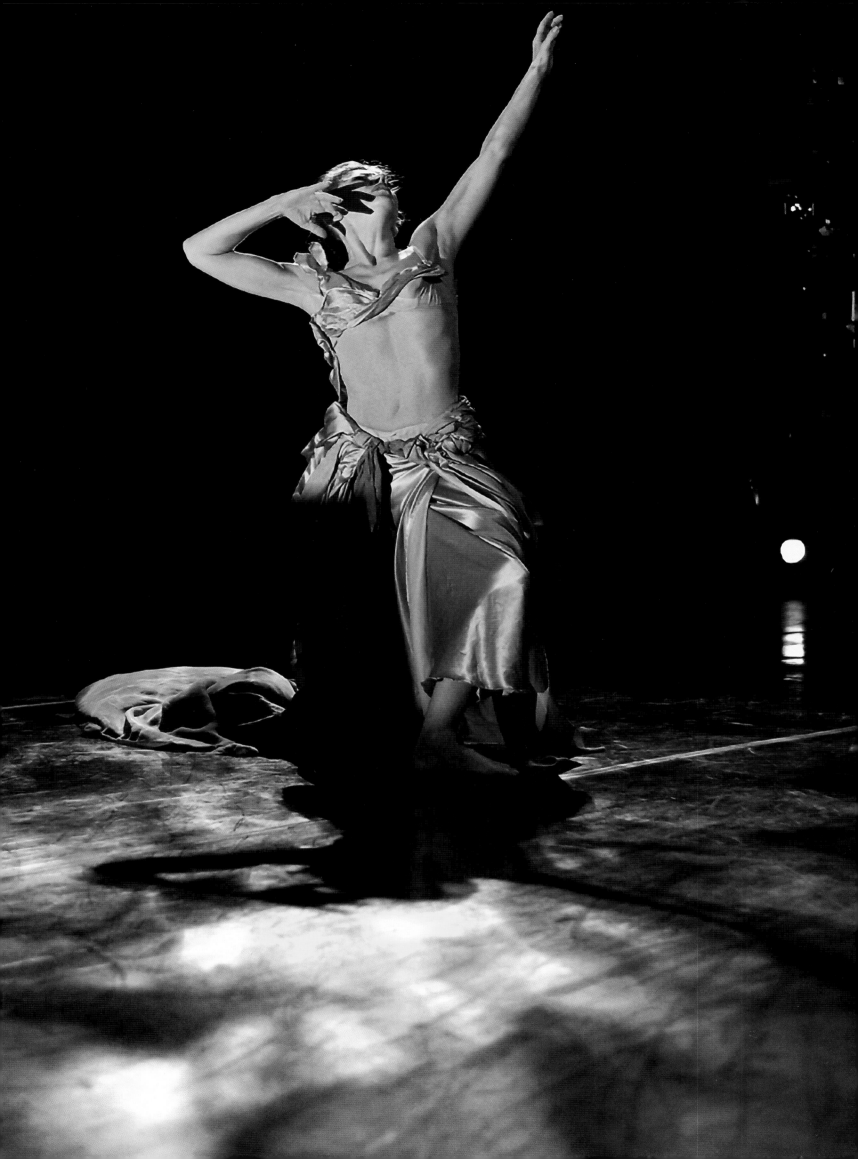

The next day brings dress rehearsals at the school. The Dance Showcase is tomorrow night. The stage is dimly lit for these performances. The lighting technicians are youthful types with matching eyesight. Maybe it's the two days of practice, but I'm getting pretty good shots. Later, back at the print shop, something has to give. I need a photo to give to Mickey, one for myself and if I'm smart I'll make a copy for the stage manager, Farley, because without light there are no pictures. I start one batch and decide to size them at 4x6. They'll print faster and if I use a certain fine paper they'll look like antique postcards.

Soon it's Friday morning, I have fifteen photos to bring to school, plus three 11x17s. It's quite a batch of work, and I have an extra set for Farley, too.

The photos are very well received. It's like Christmas day at LaGuardia. Even the pianist, Cedric, is pumped. The shot of him in the spotlight is a winner. Everyone is excited. Now I can relax, the show isn't until four, but one student, Catherine, has lost her headshot and everyone but her will have their photos on display in the lobby. "Get changed and meet me in the studio." I take the photo and return to the apartment, getting back to the school with her headshot just as the display panels roll out on their way to the lobby. The displays are full, but if they remove the sign that reads "Photos by Frank Peters" they'll have room for Catherine. It's done and off the panels go.

Now, time to find Farley. Of course, he's nowhere to be seen. It's just minutes before the curtain goes up and I assume he'll be tight as a drum. So when one of the technicians calls him down to the stage to "have a word with Mr. Peters," I'm fretful that now's not the best time to hand him a stack of photos. Down he

comes, looking cool as a cucumber. "Thank you," he graciously accepts my photos.

I retreat to the lobby; half the fun for me is observing the reaction the photos get. I can hang back and see the parents and siblings gather in the lobby, mingling around the photos. You can tell who's here to see whom; everyone points. A few moments later everyone has been seated. I move into the theater just as the lights go down and the show begins.

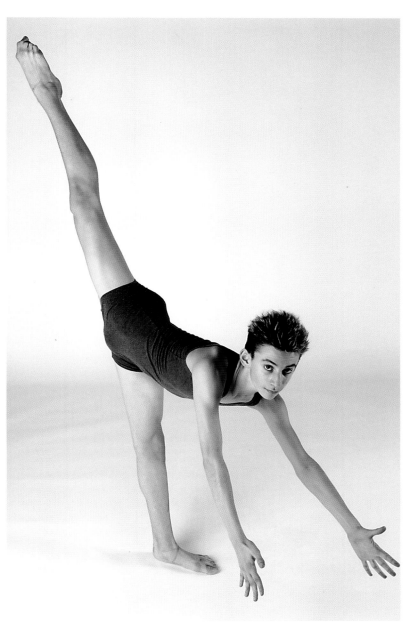

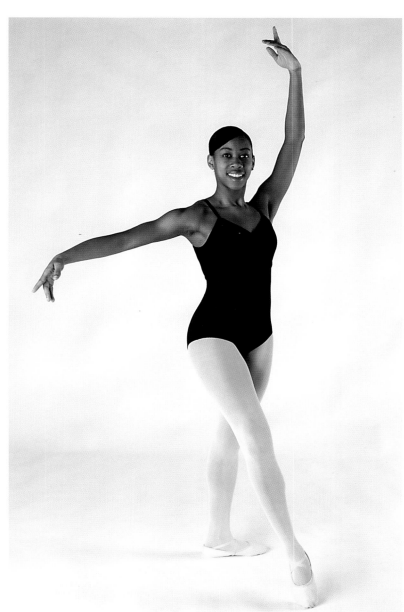

Adam Barruch, Catya Craig

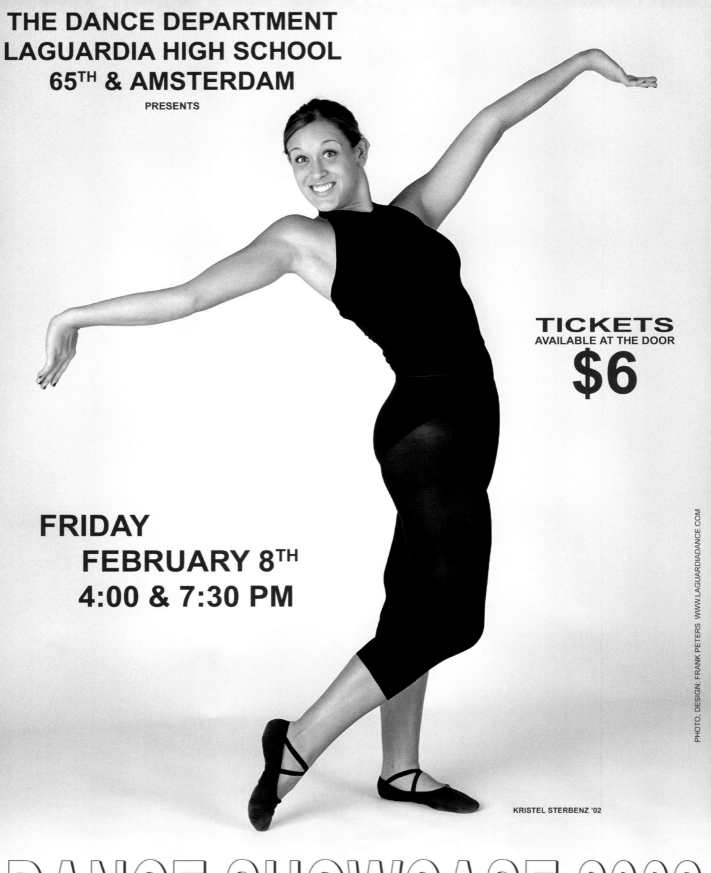

**THE DANCE DEPARTMENT
LAGUARDIA HIGH SCHOOL
65TH & AMSTERDAM**
PRESENTS

TICKETS
AVAILABLE AT THE DOOR
$6

**FRIDAY
FEBRUARY 8TH
4:00 & 7:30 PM**

KRISTEL STERBENZ '02

PHOTO, DESIGN: FRANK PETERS WWW.LAGUARDIADANCE.COM

DANCE SHOWCASE 2002
LAGUARDIA HIGH SCHOOL

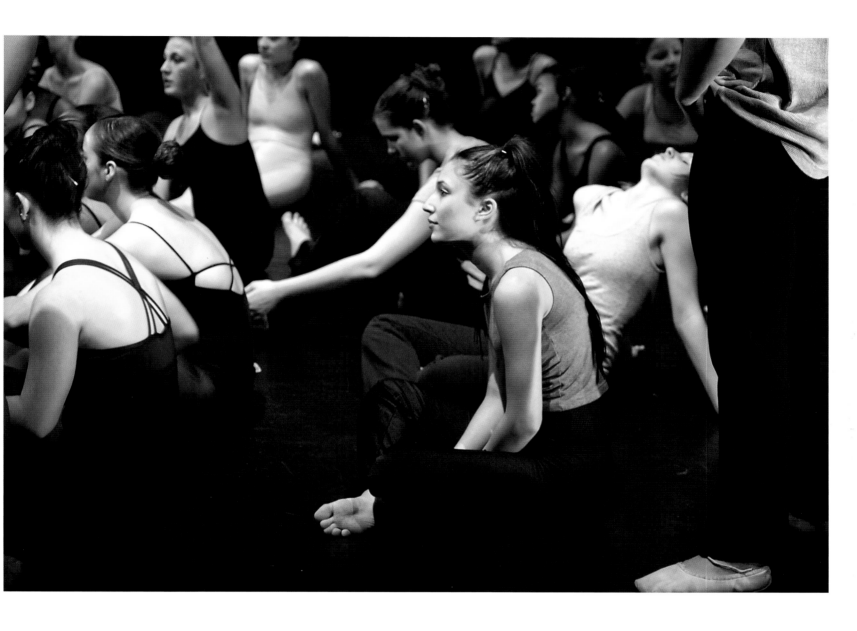

Ronak Ghajari

The theater is nearly full. Mickey makes her entrance all dressed in black. She'll come out between the dances to say a few words and give the dancers time to change costumes. Then there's a surprise, and I sense it before she gets all the words out. "Can I get the house lights up? No? I don't know where he's sitting," she begins. In the darkness of the auditorium I get a round of applause for my photography contributions.

There's an overflow crowd for the 7:30 show. The security staff has to clear people from the aisles. There must be a thousand people in here. I get a seat

Michelle Mathesius

early. Mickey walks down the aisle in time for me to say, "It's a sellout!" This time she knows where I'm sitting and the house lights are up. It's just an instant; the recognition is very gratifying. This is what retirement is supposed to be.

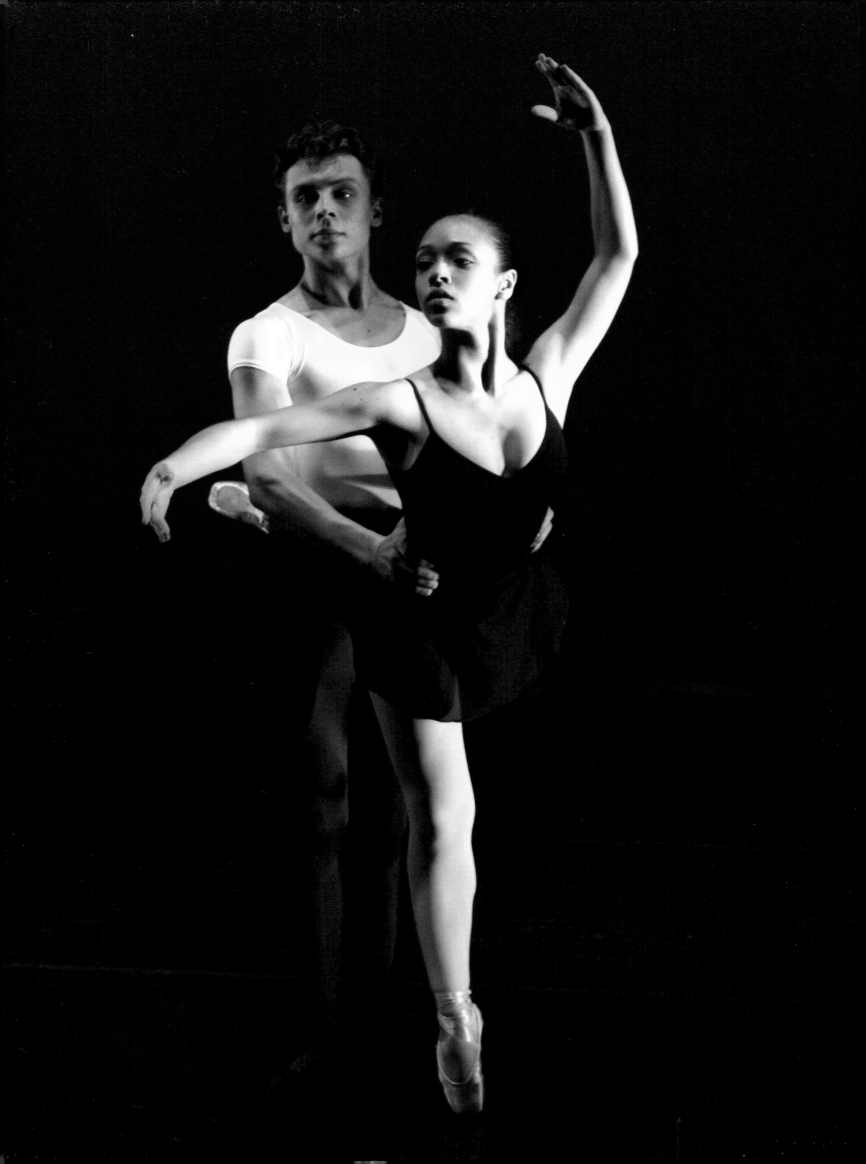

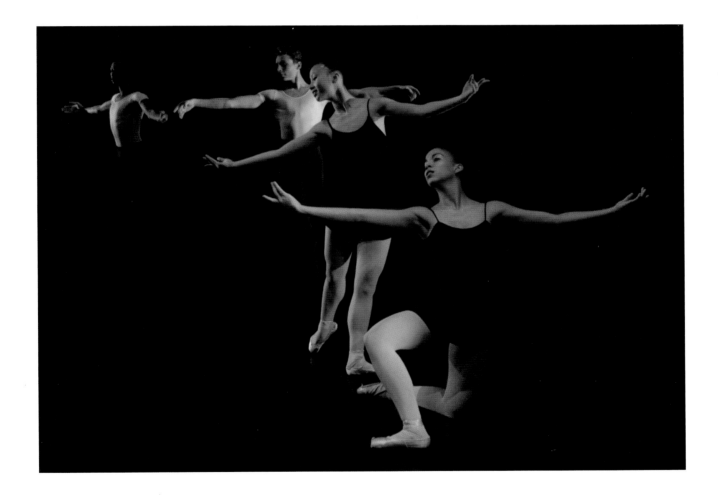

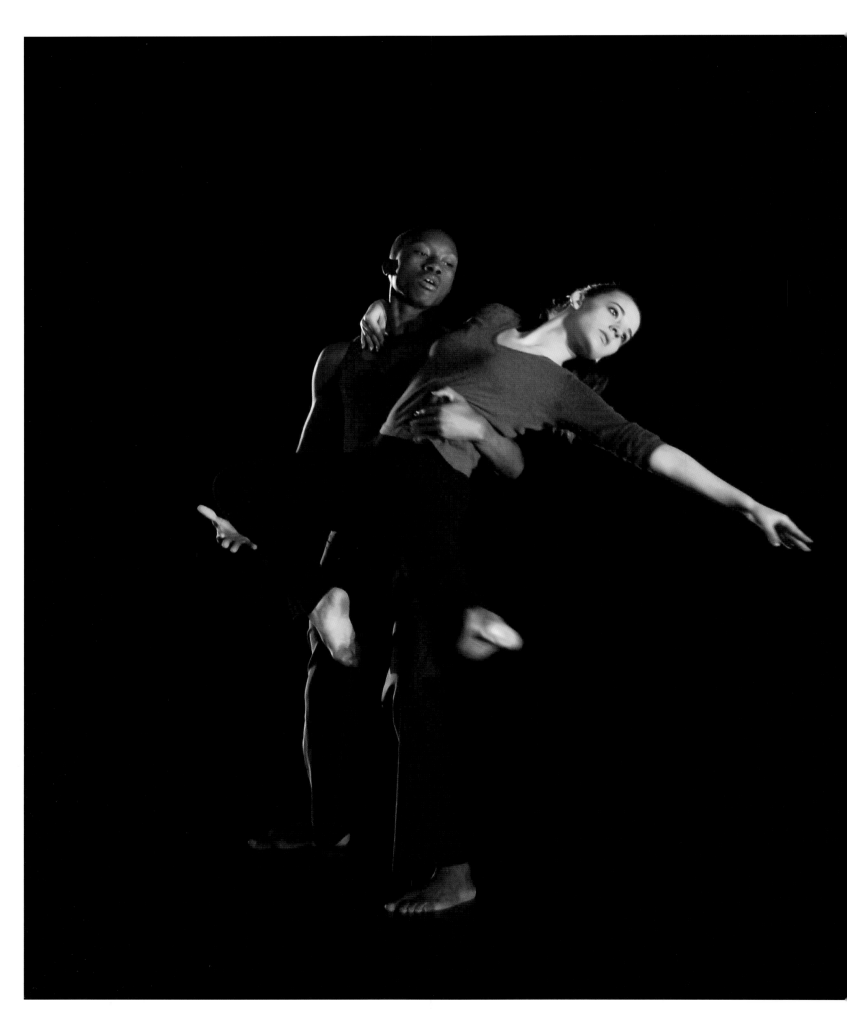

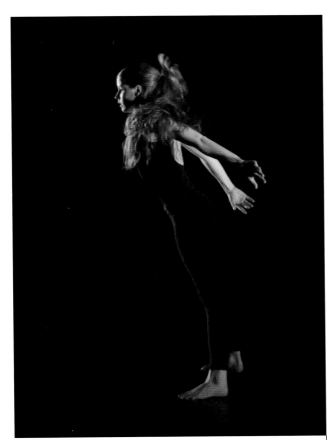

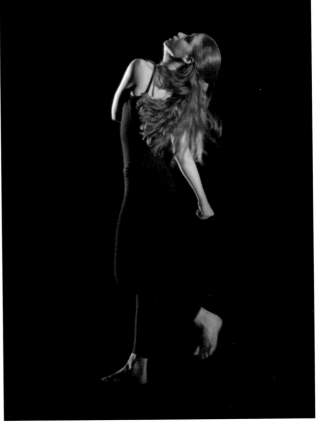

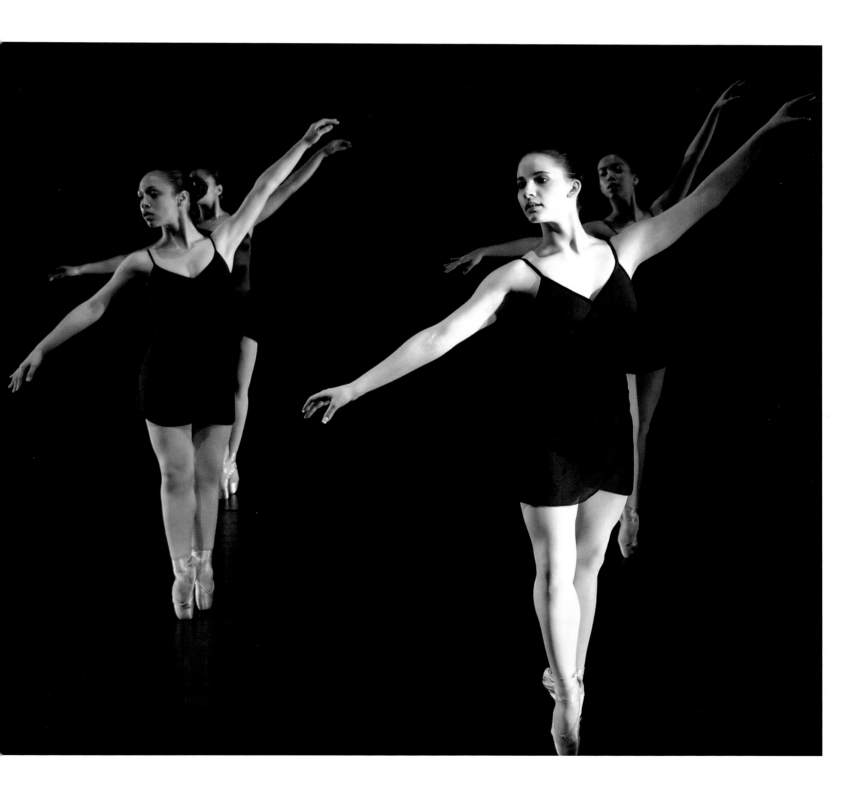

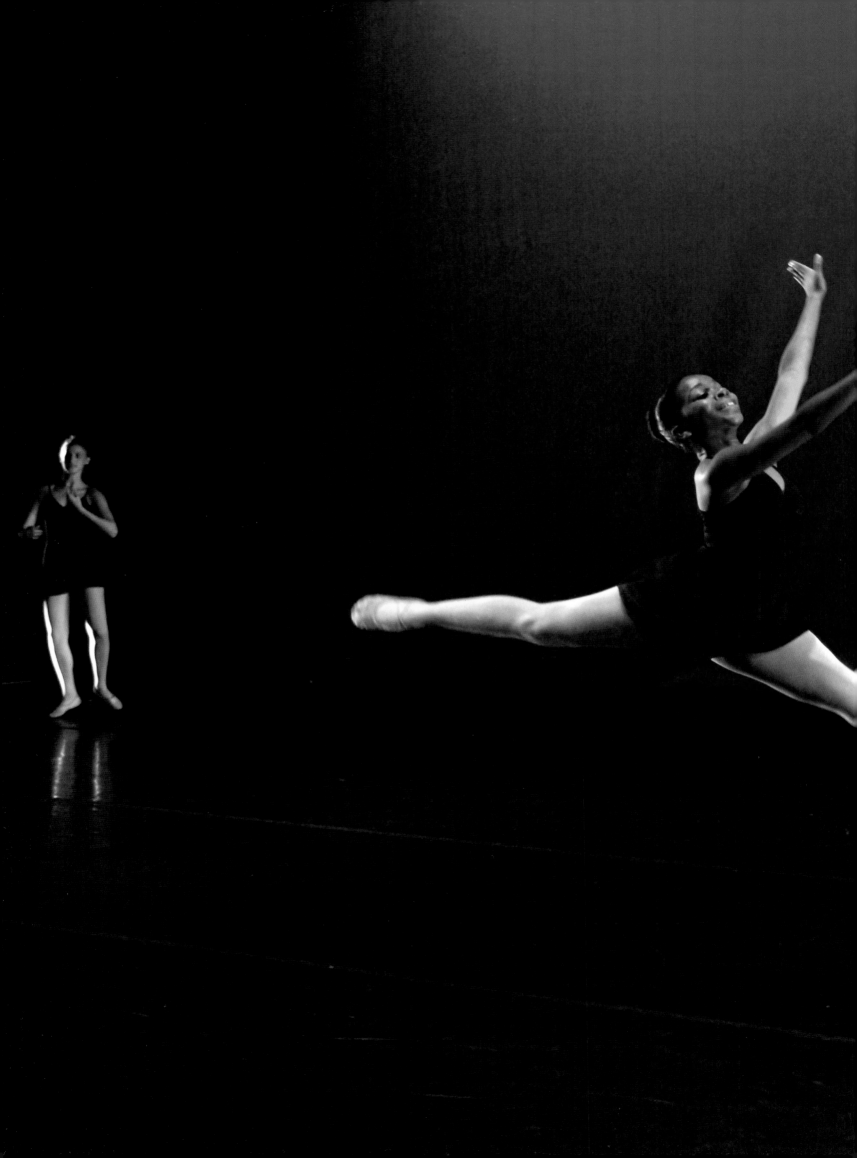

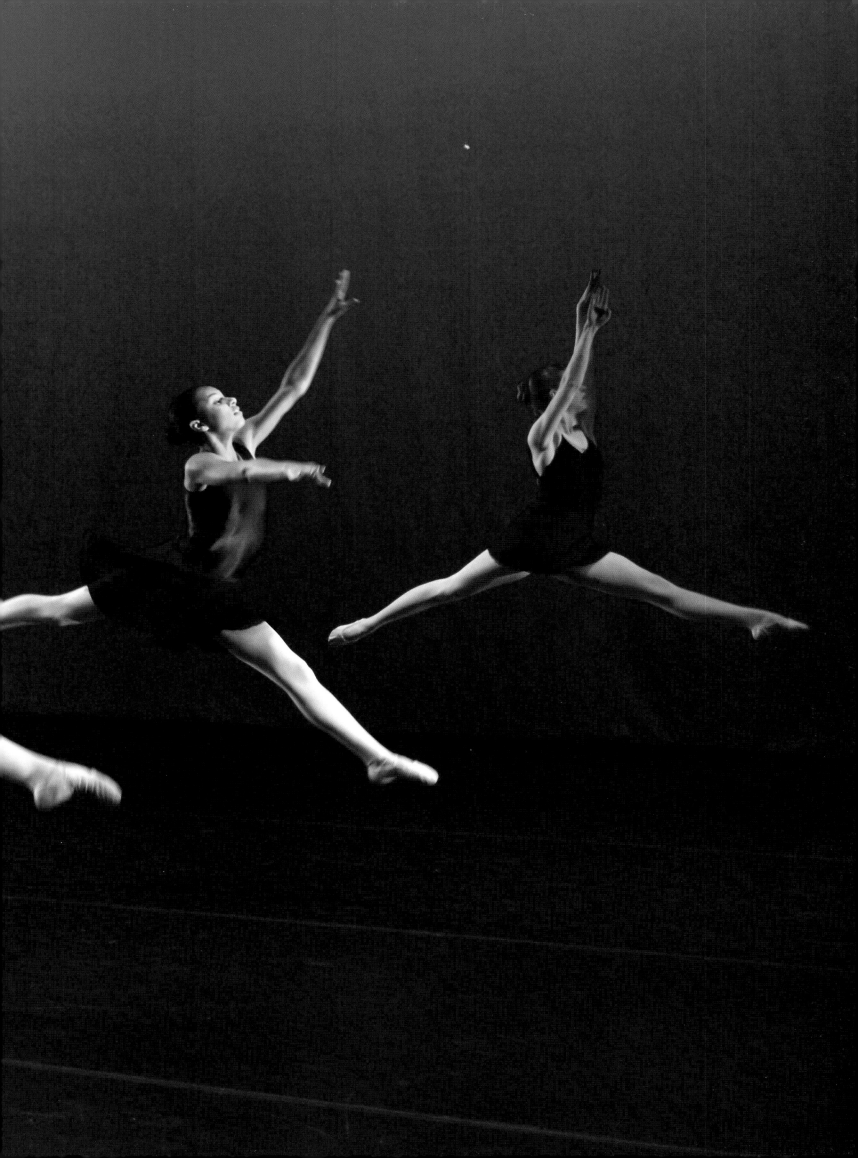

APPENDIX

GUESTS AND TEACHERS

Frankie Manning

Donald McKayle

Mary Anthony

Harry Asmus

Valerie Bettis

Shirley Broughton

Jacqulyn Buglisi

Nenette Charisse

Leon Danielian

Frederic Franklin

Eve Gentry

Martha Graham

Diane Gray

Hadassah

Mary Hinkson

Stuart Hodes

Geoffrey Holder

Hanya Holm

Marian Horosko

Gerri Houlihan

Lucas Hoving

Doris Humphrey

Ann Hutchinson

Robert Joffrey

Nora Kaye

Bruce King

Pauline Koner

Valentina Kozlova

Nancy Lang

Pearl Lang

Frankie Manning

Thalia Mara

Sophie Maslow

Matteo

Donald McKayle

Carmen Morales

Jennifer Muller

Libby Nye

May O'Donnell

Nina Popova

Elizabeth Rockwell

Bertram Ross

Doris Rudko

Marion Scott

Gertrude Shurr

Maria Tallchief

Charles Weidman

Ethel Winter

Robert Wood

Matthew Neenan

Talley Beatty

Janis Brenner

Mary Brienza

Carol Bristol

Jacqulyn Bulgisi

Pat Catterson

H.T. Chen

Selma Jeanne Cohen

Jose Coronado

Chuck Davis

Miguel Godreau

Zvi Gotheiner

Gabriela Granados

Krystal Hall-Glass

Gerri Houlihan

Victorio Korjhan

Joe Lanteri

Abigail Levine

Bella Malinka

Erin Martin

Matteo

Dianne McPherson

Jennifer Muller

Matthew Neenan

Carl Paris

Igal Perry

Eleo Pomare

Janet Rowthorn

Shapiro & Smith
Dance

James Sutton

Paul Taylor

Violette Verdi

Susanne Walker

Septime Weber

Igor Youskevitch

H.T. Chen

LAGUARDIA'S DANCE ALUMNI

Janet Aaron

Bruce Becker

Troy Blackwell

Olivia Bowman

Brenda Braxton

Julius Brewster

Jacqulyn Buglisi

Gregg Burge

Zelma Bustillo

Linda Caceres

Cora Cahan

Michael Callen

Gary Chapman

Raquelle Chavis

Rebecca Chisman

Gary Chryst

Keisha Clark

Jessica Cohen

Pamela Cohen

Richard Colton

Starr Danias

Ruth Davidison

Altovise Gore Davis

George de La Pena

Gemze De Lappe

Denise De Sousa

Veronica De Sousa

Melissa De Soysa

Laura Dean

Tomas Detrich

Michael Di Lorenzo

Donna Di Meo

Dennis Diamond

Matthew Diamond

Aaron Dugger

Rosemary Dunleavy

Donna Edge

Kerri Edge

Jean Emile

Charles Epps

Louis Falco

Lola Falana

Daphne Falcone

Eliot Feld

Charles Feruggio

Carol Fried

Lorraine Fields

Karen Ford

Noah Gelber

Darren Gibson

Miguel Godreau

Ellen Graff

Krystal Hall

Gary Harris

Bruce Heath

Christian Holder

Roger C. Jeffrey

Kevin Jeff

Shaun Jones

Lynne Jackson

Tai Jimenez

Mari Kajiwara

Eartha Kitt

Jane Kosminsky

Andre Kulyk

Minou Lallemand

Baayork Lee

Keith Lee

Abigail Levine

Daniel Lewis

Priscilla Lopez

Bruce Marks

Vicki Margulies

Susan McLain

Sumayah McRae

Leonard Meek

Hector Mercado

Jane Miller

Joan Miller

Liza Minnelli

Arthur Mitchell

Peff Modelski

Carmen Morales

Tony Mordente

Scott Morrow

Eliana Munier

Matthew Neenan
Elizabeth Pape
Carl Paris
Michael Peters
Valerie Pettiford
John Parks
Eleo Pomare
Troy Powell
Coco Ramirez
Keith Randolph
Desmond Richardson
Jonathan Riseling
Anthony Rodriguez
Jamie Rogers
Polly Rogers
Brunilda Ruiz
Ramon Segarra
Lolita San Miquel
Eddie Shellman

Lance Sherman
Victoria Simon
Katarzyna Skarpetowska
Dwanna Smallwood
Risa Steinberg
Kim Stroud
Eddie Stockton
Lee Theodore
Nasha Thomas
Suzanne Vega
Ben Vereen
Edward Villella
Norman Walker
Dennis Wayne
Melinda Welty
Allison Williams
Dudley Williams
Vanessa Williams
Michelle Yard

123

*Roger C. Jeffrey '92, left, dances with Mikhail Baryshnikov's
White Oak Dance Project in Essen Germany.*

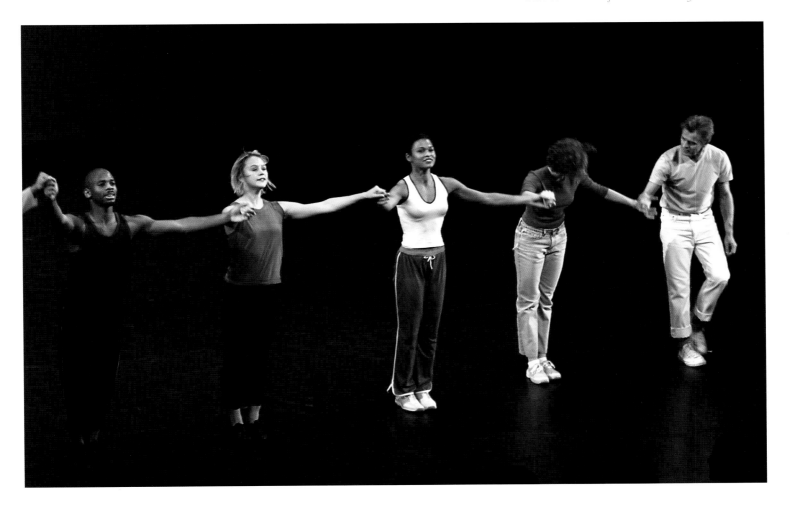

PHOTO INDEX

16-17

Armando Braswell *Fallon Preziotti*

18-19

Jashiro Dean *Monica Lorenzo*

20-21

Meagan Keller *Hailley Schwartz*

22-23

Valerie Miller,
Miss Petite Teen New York *Gina Wren*

24-25

Victoria Migliaccio *Roger F Prince*

26-27

Kirsten Carter *Monica Lorenzo,*
Crystan Minutillo,
Jillian Guella,
Dorothy Mindur

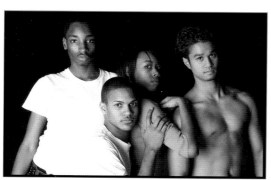

28-29

Victor Reddick, Jashiro Dean, Catya Craig, John Paul

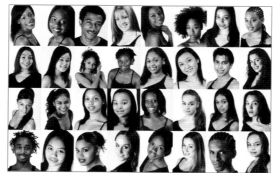

30-31

TOP: Syreena Campbell,
Juanita Mack, Jeremy Nedd,
Michelle Campbell, Michelle
Rodriguez, Maiko Mori, Jennifer
Rojas, Tariqua Nehisi, Crystan
Minutillo, Bhaminie
Jagindhrall, Amber Parker,
LiAnne Wheeler, Calvin Booker,
Maricah Sermeno, Jody
Henriquez, Haley Dulman

TOP: Sade McCaleb, May Alice
Wells, Barbara Miller,
Jessica Watson, Shamika Carno,
Lu Guo, Viktor Bernardo,
Jillian Guella, Alanna Morris,
Maxine Gurevich, Jill Javier,
Thulinh Mactruong, Annisha
Smith, Jessica Piervicenti,
Rowan Johnson, Geneva
Hernandez

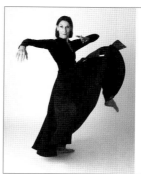

32-33

Deborah Zall *Joey Smith, Catherine Brikké*

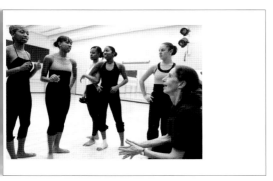

34-35

Sequana McClary, Catya Craig, LaToya Demps,
Kinda Romero, Paula Haim, Penny Frank

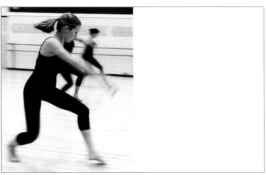

36-37

Meagan Keller

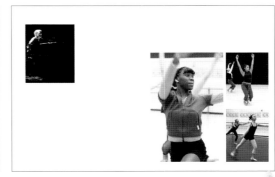

38-39

Cedric Tolley *Karen Guedez and Mayte Natalio,*
Xiaolin Fan and Melissa
Timothy-Tozer, Nikema Harrell

40-41

Elisa King

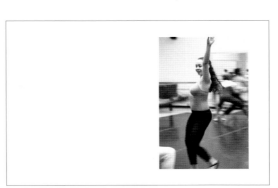

42-43

Valerie Miller

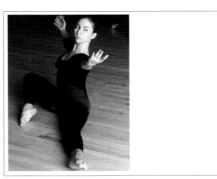

44-45

Anna Chetnik

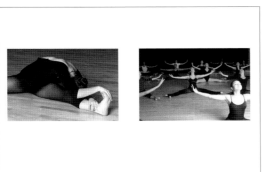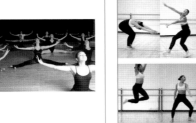

46-47

Anna Chetnik *Geneva Hernandez*

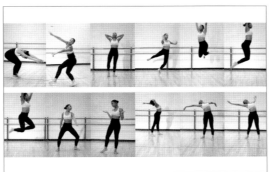

48-49

Candyce Barnes

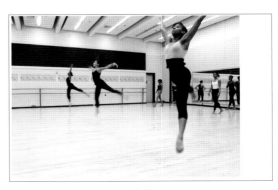

50-51

Ronak Ghajari and Catya Craig

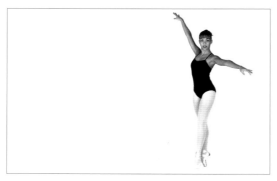

52-53

Ana-Cristina Lebron

54-55

Loni Landon & Emily Oldak

56-57

Mohan Jean-Mary Shamel Pitts, Mohan Jean-Mary,
and Jamie Pierrepont Ryan Rankine

58-59

Hayley Ballard Karen Guedez

60-61

Juanita Mack, Yudermy Blanco, Calvin Booker

62-63

Candyce Barnes Alexandra Rosen
Alexandra DeLeon

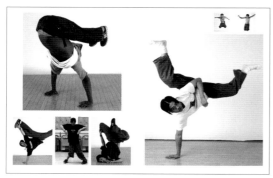

64-65

Peter Toussaint Jason Wong
Matthew Hall David Peters
* Mark Peters*

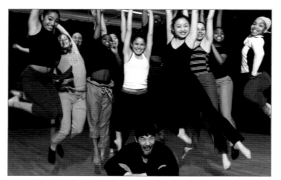

66-67

H.T. Chen and the Class of 2001

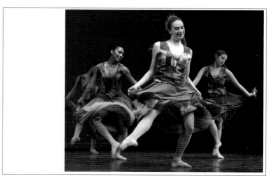

68-69

Karen Guedez, Fallon Preziotti, Barbara Kontarovich

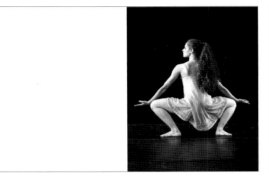

70-71

Emily Oldak

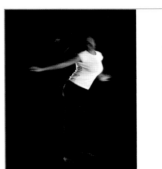

72-73

Natalie Cohen

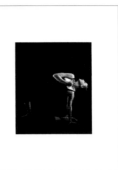

Ava Heller

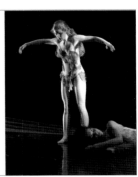

74-75

Maxiel Wilmore

Kathleen McGuire

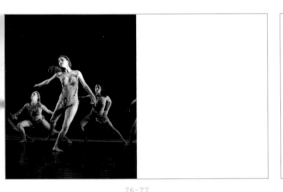

76-77

Alexandra Rosen

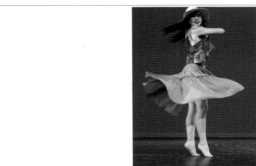

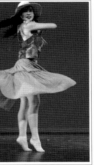

78-79

Alina Nevada Diebold

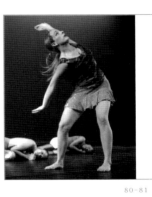

80-81

Jac'Lynn Ronne

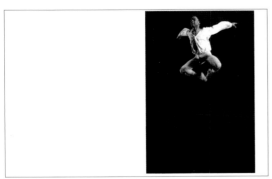

82-83

Ryan Rankine

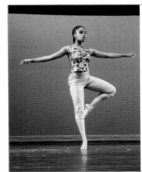

84-85

Mouna Mills

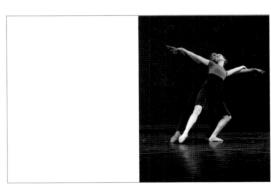

86-87

Loni Landon & Randy Castillo

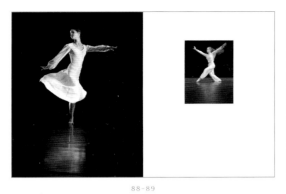
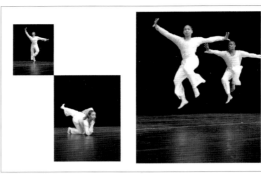
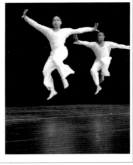
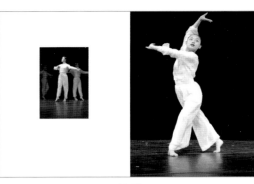

88-89

Kristen Antzoulis *Emily Oldak*

90-91

Mouna Mills, Anna Chetnik *Mayte Natalio
and Armando Braswell*

92-93

Chi Shi *Li Jun Li*

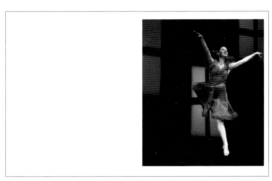
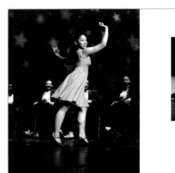
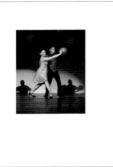
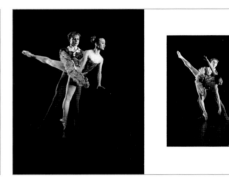

94-95

Loni Landon

96-97

Lisa Resuta *Lisa Resuta and Matthew Hauer*

98-99

Xiaolin Fan & Roman Zhurbin

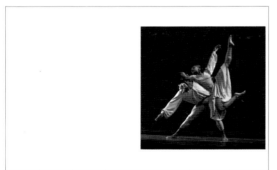
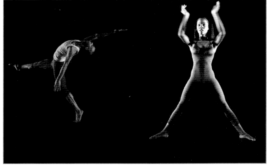

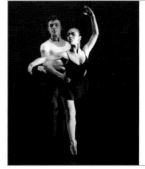

100-101

*Ryan Rankine and
Mohan Jean-Mary*

102-103

Shamel Pitts *Keri Roberts*

112-113

Roman Zhurbin and Jesana Colon *Angelique Rivera,
Xiaolin Fan,
Roman Zhurbin*

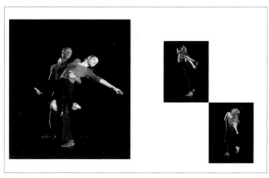
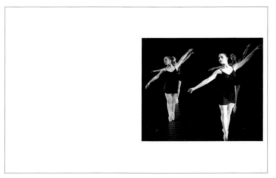
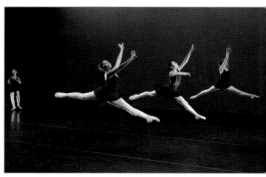

114-115

*Ramiah Mowatt
and Kristin Engesser* *Kathleen McGuire*

116-117

*Jesana Colon,
Kristin Engesser,
Ana-Cristina Lebron*

118-119

*Alexandra Rosen, Mohan Jean-Mary,
Melissa Timothy-Tozer, Kathleen McGuire*